Drawing by
Sea &
River

Drawing by
Sea & River

John Croney

NORTH LIGHT CINCINNATI OHIO

© John Croney 1985
First published in North America 1985 by
North Light, an imprint of
Writer's Digest Books
9933 Alliance Road
Cincinnati, Ohio 45242

Library of Congress Cataloguing in Publication Data
Croney, John
Drawing by Sea/River
includes index
 I. Marine Drawing – Technique, I. Title
II. Title: Drawing by Sea/River
 Nc 817. C76 1985 743′837 84–25503
 ISBN 0–89134–104–8

Contents

ACKNOWLEDGEMENT 6

INTRODUCTION 7

ART AS INSPIRATION 8

DRAWING MATERIALS 10
The pencil 10
Papers 11
Pen and ink 11
Brush and wash 12
Gouache 13
Charcoal 14
Chalks 14
Pastels 14
Heightening 14
Pencil and eraser 14

PRACTICAL PREPARATION 15
Finding a subject 15
Outdoors 15
Preparing to draw 15
Working at home or in the studio 17
Starting a drawing 17
More about lines 20
Composition 20

THE SEA AND RIVER 23
The sea and water as a flat plane 23
Waves 26
Headlands, cliffs and rocks 34
Coastal features 48
Rivers and inland water 54

THE SKY AND CLOUDS 71
Cloud studies 77

BOATS 83
Boats and sketch-book work 83
Ropes, tackle and moorings 86
Beached boats 88
Moorings and harbours 96
Repair and scrap yards 109
Inshore boating and sailing 109

SHIPS 120
Sketching ships 120
Sketch-book studies 128
Ships and docks 130
Ships sailing 139

POSTSCRIPT 142

INDEX 143

ACKNOWLEDGMENT

I must mention my father who I believe first awoke in me a love for the sea. Many winter evenings I sat enthralled by the fire whilst he told me tales of his seagoing experiences in the Royal Navy during the First World War. His descriptions were very graphic so that even now I can remember some of them, and when I was young they formed the subject of many of my drawings.

Miss Penelope Long, and the Library staff of the Sanderstead branch of the Croydon Library services, must be thanked for their kind and ever ready assistance in discovering reference material.

I am most grateful for all the guidance and advice received from Mr Reginald Williams and Mr Paul Goldman of the Department of Prints and Drawings in the British Museum. They were a great practical assistance in locating drawings that were useful in the preparation of the book, as well as in its final formation.

I must thank the Department of Paintings and Sculptures, The Brooklyn Museum, New York for their courtesy in allowing me to use Winslow Homer's watercolour drawing *Through the Rocks*. Also my thanks to Mrs Carol Danes for allowing me to use L S Lowry's drawing *Boats*.

I must thank Miss Joyce Gadsby who by her excellent typing made the preparation of the manuscript so much easier.

Thelma M Nye of Batsford has been her usual tower of strength, and I must thank her for her enthusiastic support and advice, and for her assistance in obtaining new material and illustrations.

Finally I must remember my wife, who, as always, has helped me in so many ways. To her I owe a special thank you for managing to live with, and amongst, the extraordinary and evergrowing, mixture of paper, reference material, photographs, models and art materials that proved necessary for the birth of this book.

Croydon 1985 JC

Introduction

Jung wrote of his first experience of water: 'I could not be dragged away from it. Waves from a steamer washed up to the shore, the sun glistened on it and the sand under it was curled into little ridges by the waves' . . . 'its expanse was an unconceivable pleasure to me, an incomparable splendour'. If we love the sea, this enchantment returns each time we reach it, and we are in a situation where sketching, however slight, stands a very good chance of success.

The sea, or any expanse of water, possesses a compelling fascination; it is not only that it has a mystical power bound up with creation and the age of the earth or that it is connected with dreams – but it is so physical. It captivates in all its moods, whether it is quiet and calm, or throwing up little columns of droplets against rocks; or when it is rough and noisy, tipping and tilting boats, and crashing onto shingle. As well, of course, there is the change in its appearance caused by the variation in the range of natural lights which can play on it. In a short time the same scene may change from bright and clear to being misty or sombre.

Expanses of sea and water, and the activities that go with them, always present a series of absorbing visual events and therefore an almost endless variety of pictorial images. We can either distance ourselves from these events and find compositions with a haunting emptiness, where the vastness of water and sky are relieved only by small forms of clouds and distant specks of shipping, or where the drama of a storm or the beauty of atmospheric effects and light create a composition of their own; or we can remain near our subject and explore the construction and rigging of boats, superstructure of ships, as well as details of cranes and wharves, cliffs or coastal rock formations. Additionally, rivers, lakes and lochs have a variety of life which provides much subject matter. Small harbours and moorings will contain many types of boats, motor cruisers and yachts. The moorings themselves, sandbanks, bridges, trees, waterside buildings, fishing gear and docking equipment provide extra complexities and unrivalled pictorial material.

Perhaps one way to define beauty is to represent a seascape or water piece as we see it. Because of the wide range of human temperaments there are still a thousand and more ways remaining to do this by discovering new points of view, and it is hoped that this book will aid its reader in this happy quest.

All drawings by the author unless otherwise stated

Art as Inspiration

In drawing and pictorial art, the use of the sea and ships as subjects for art goes back a very long way in man's history. Artists from many cultures have taken inspiration from the exploits of their sailors and ships; and they have also been called upon to represent and record the changing shape of the ships as one revolution in sea transportation succeeds another. In recent centuries maritime art has been preserved in collections and has served to fuel the inspiration of every new generation of artists.

Marine art or sea pieces, up to the end of the eighteenth century in the West, were generally very factual. Sails and yards and the controlling rigging, hull shape and detail had to be accurately portrayed. In most cases a sea piece was a ship's portrait, the artist often having been a serving officer afloat or an artist carried as part of a ship's complement. Ships' models were used so that every pulley and piece of rope could be studied to increase the accuracy of the portrait. When the ship's portrait ceased to dominate, artists turned their attention to a variety of marine appearances and effects of light. Their subject matter included the first canals and tugboats as well as a steadily increasing number of harbours and docks.

The two greatest artists of the time were JOHN CONSTABLE (1776–1837) and WILLIAM TURNER (1775–1851). They were two contrasting spirits in their individual aims, yet they can now be seen to complement each other in the advance of landscape and seascape painting.

In the dramatic compositions of Turner we can rarely identify a ship's portrait, yet upon greater acquaintance we become aware that each of his works has the soundest of structures and that his extended titles serve only to list the natural forms and effects he used. Constable's searching beach scenes have moved a long way from the carboard seas and lifeless ship models of the mid-eighteenth century and provide practical insights to his belief that 'what are the most sublime productions of the *pencil* but selections of *some of the forms of nature*'. Both of these artists made much use of sketchbooks to obtain material for pictorial use.

A canal scene for Turner was a composition of boat shapes, whilst Constable thought an artist should strengthen himself by direct experience and should try and find truth of form and atmosphere by drawing from nature. They both searched in natural forms for the sublime. They both showed how the very ordinary could be translated into pictorial art.

Other important artists active at this time were DAVID COX (1783–1859) and JOHN SELL COTMAN (1782–1842) who were exploring coastal, estuary and beach scenes. They, together with many of their contemporaries, also found a new subject matter in inland waterways.

The activities of these artists increased the range of subject matter for seascape artists that followed them. Most importantly they assisted in the growth of a more natural everyday vision, and they bequeathed to their successors the freedom to attempt all manner of river and coastal scenes, as pictorial subjects, in varying weathers and times of day.

In Holland, many influential marine artists were active in the seventeenth century of which perhaps the most well known was WILLEM VAN DE VELDE THE YOUNGER (1633–1707). He died in London and left a rich heritage of his work to museums throughout the country. He was equally admired by the ships' portraitists, and later by Romantic artists,

for his ability to depict the effects of gales and breezes on clouds and waves.

In France in the 1830s and later, a group of artists gathered in the village of Barbizon. They had as their aim *natural landscape*. Inspired by Constable they devoted themselves to outdoor landscape works. They drew and painted river scenes, valleys, farmlands and workers, rocks and forests. This was a new and fresh form of realism. Artists prominent in this group were GUSTAVE COURBET (1819–1877), JEAN-BAPTIST COROT (1796–1875) and FRANCOIS MILLET (1814–1875). Each was a revolutionary who painted original landscapes which are still influential.

The inventor of Impressionism, CLAUDE MONET (1840–1926) admired and studied the works of the Barbizon artists, and particularly that of CHARLES DAUBIGNY (1817–1878) who became a lifelong friend and who assisted Monet in his artistic career. Daubigny loved painting river and coastal scenes. Besides Daubigny's subject matter, Monet was impressed by the lack of pretence and the directness and candour that he saw in his technique.

Monet as a young man was already attracted to the sea when he met EUGENE-LOUIS BOUDIN (1824–1898). He was happy to learn from a painter who painted on the spot effects of sunlight and the movements of the sea. They painted many sea pieces together in the open air. 'The ocean is so beautiful' Monet said. He revelled in the sea and skies and scenery of the Normany coast, and in working from the beaches and amongst the rocks. The titles of his work show how immersed he was in his subject matter. They include *Seaside Terrace, Beach, Jetty, Boats in Harbour, River Scene, The Port, Cliffs, Cape, Fishing Nets, Coast, Fishing Boats, Sailboats, Iced-over River, Flooded River*, and so on. This list of titles is striking because it is an almost comprehensive coverage of sea and river subjects; and for our purposes well worth knowing. Should we need refreshment or inspiration, Monet must be one of the artists to whom we turn first. He shows a more complete grasp of naturalism than any other artist; his drawing is remarkable because of his keen eye for tone; and light and joy are in all his works.

Space does not permit me to extend this brief history to the present time; but two artists must be mentioned. They are JAMES MCNEILL WHISTLER (1834–1903), and WINSLOW HOMER (1836–1910). Both were from a Massachusetts background; they also had in common a desire to see the world with fresh eyes, and both made dynamic drawings of ships and the sea of great originality and beauty.

Drawing Materials

Drawing as an art is unique in that it interprets a subject on its own terms, and those terms are the variety of marks that can be made by various materials on a drawing surface. Sickert, when admiring Whistler's sea pieces, said 'He will give you in a space nine inches by four an angry sea, piled up and running in'. One of the great pleasures of making drawings of the sea and sea views is that on quite a small sheet of paper it is possible to capture a large dramatic or picturesque effect. Three dimensions are imagined and from this base the most haunting images can be built up, and all manner of emotional meanings extracted from different markings, tones, textures and linear rhythms.

To enjoy fully, and be able to exploit the drawing process, a good knowledge of the extent and type of materials that can be used is necessary. In the following list I have tried to be as comprehensive as possible, and in certain cases have described how materials can be used together, or have given 'tips' based on my own experience with them.

The pencil Generally a slim rod of graphite contained in wood. But graphite sticks can be bought to be used in a holder. Pencil techniques have been developed extensively during the present and last centuries. The simplicity and purity of the lines they make present a great challenge and have certain limitations. Pencil work is often considered instructive because, once mastered, if ease of execution can be attained with it, then it would seem to follow that ease of execution can be attained with any other material. However there is no reason why a beginner should persevere with the pencil to the point of unhappiness. Turn to other materials for a change, and then return refreshed to a pencil.

Pencils can be obtained with either harder or softer graphite. They are graded from 6H (very hard) through to 6B (quite soft), an HB pencil being halfway between the two extremes. It is a good idea to try all the grades at some time or other, gradually learning to mix two or three different grades in one drawing. In this way the varying qualities of mark obtained can be appreciated. I would suggest a B or 2B pencil is a good grade to start with, but this is not an absolute rule. Certainly H or 2H, and so on, are difficult to use expressively because they offer such a fine line of great purity. They are more likely to be found in a drawing office for technical work. However, I still use them on occasion and they should certainly be tried. It is a comfortable feeling to have a fairly large stock of pencils readily to hand, and all well sharpened, so that you can pick them up and use them without pause.

It is also possible to get extra thick pencils, the *Black Beauty*. This is about equivalent to a 4B pencil. Its extra weight and larger lead makes it good for larger work, for it can give a broader and heavier effect.

The leading manufacturers of artists' materials also make a range of coloured pencils. These are a pigmented crayon all of the same grade. They are generally offered in about twenty-four colours including black and white. They can be used with graphite pencils, and are best when blended in to give greater luminosity or warmth, or coolness to a pencil drawing. They do not have the resonance or power for use as area fillers.

Conté pencils are another very useful form of pencil. They are composed of clay and graphite, and are therefore softer and give broader effects than the graphite pencil. They are made in varying grades in

black and earth browns and reds. They make a very convincing mark, with the immediacy of pen and ink work, but they can be erased. They offer the opportunity of strong bold drawings, although even their strongest line has a softness to its edges. The *Conté* crayon, in the form of a short, small square stick, is also a valuable asset to the artist, giving a broader line. Also, with practise, distinct nuances can be made when the crayon is new. *Conté* looks very well on coarser toothed paper when it is used to reveal the grain as a white sparkle.

Pencil work of whatever kind should eventually be fixed; heavily built up pencil work should be fixed without delay. Fixatives are supplied in aerosol cans or as a liquid with a separate spray diffuser. In most cases, the application should be made from about 20 to 25 cm distance from the drawing, the spray being moved along so that 'pools' of fixative are not left on the work. It may be necessary to give more than one application.

Papers These are offered in a very wide range and, like pencils, it is best if in due course all the different qualities are tried.

For a start, students' and then artists' white cartridge paper is adequate. You will notice that one paper description is by weight; the artists' paper, being thicker, will weigh more than the students'. This extra weight will be necessary once you start to scrape out parts of your work with a knife or use a damp sponge for special effects. The heavier papers will stand rougher handling. If you go over a line again and again with a sharp pencil it will eventually go through the lighter paper, so for a straightforward drawing in 2B pencil a students' paper could be adequate, but for a mixed media drawing, which will be very overdrawn and rubbed and scraped out, a much heavier paper is necessary.

The better quality or heavier papers are generally listed as watercolour papers. A moderate-priced sheet will be about ten times the price of a pencil. Good paper is expensive and very good paper very expensive. However, it is the foundation of a drawing and, once some confidence has been obtained, better quality papers will be found to give better results.

The heavier papers are offered with different types of surface. Rugged or rough means what it says – the paper surface has an almost visible *tooth*, which certainly becomes visible if you run a crayon or wash rapidly across it. The crayon or wash will come off on the peaks of the *teeth* leaving numerous tiny white areas between. Using rough paper in this way is a very obvious means of obtaining the effect of speckled reflected light on a water surface. A hot pressed paper means that it will have quite a shiny smooth surface, the paper having been finished in the mill by being run under the pressure of a hot heavy roller. This type of paper is good for pen and ink work, and may also be found acceptable for various forms of opaque colour.

The famous names in paper manufacture are the English *Whatman*, German *Zander* and Italian *Fabriano*. First quality papers are handmade and can be recognised by their irregular edges.

Papers also have names, for example Ingres or De Wint which offer discrete types of surface peculiar to them. They, and other papers, can be obtained in a range of muted colours. These toned papers must also be tried.

Many papers have a right and a wrong side or a rougher and smoother side. In the cheaper papers this is not very obvious and either side would produce little difference. Probably the right side of a paper in the end is the side you like using.

Paper can either be fixed with drawing pins or clips to a board, or used in a sketch-book which is support in itself. For wash or watercolour work the paper should be moistened and then fixed down by its four edges to a larger board with gummed paper strips. It will appear wrinkled at first but when dry (the drying done naturally) the paper will become smooth and tight. Washes can then be applied to one's drawing without the completed work being wrinkled permanently. This is reasonably easy to do and after the first few, the process should present no problems. The completed work is cut out from the inside edge of the gummed paper strips when dry. The gummed strips are then peeled off and thrown away.

Pen and ink This is just the same material that we use for writing. It provides a very clear line, but unlike pencil the line can be made to vary in thickness by applying more or less pressure to it. It can also be smudged with a wet finger or a wet brush thus making it almost a painting technique. After long, or numerous pencil sessions, returning to pen and ink gives a wonderful feeling of liberation and freedom, but without control, it is no better friend than a pencil or any other drawing material. I often begin with small dots or marks; this allows the attainment of fairly correct proportions or distances, as well as some suggestion of depth, before

one is committed to lines or contours which, in ink, are very final.

Some may wish to sketch in pencil before using ink. Ink combines very well with pencil, and the mixture, if it were liked, could be left in the completed drawing.

Brushes and sharpened sticks can also be used with which to draw in ink. If brushes are used they should always be washed out carefully afterwards.

Brush and ink will give a varying thin to thick line, this in turn depending on the size of the brush. A round watercolour brush will give a more decorative line, a square brush a jagged rectangular effect suitable for the shadows under the crests of waves or the shadow parts of rocks.

Sticks, about 15 cm long, sharpened, to the shape of your fancy and experience, can provide all manner of staccato marks and dashes. There is a certain roughness in this technique which may, or may not, be found attractive. As a method it does not produce an immediately attractive effect; however, as one is forced by this method to think more about what one is trying to achieve, it is useful to return to from time to time.

Ink applied in areas to paper by a brush has an immediate staining effect, and, unless one is very quick, its edges cannot be softened by a wet brush even if this is desired. Most inks are also quite granular in appearance when seen in areas, and this in fact can be used to good effect in ink washes. Rapid blotting off with blotting paper will decrease the staining effect and spread and lighten the granulation. All this should be experimented with from time to time, and is particularly useful for sky work. Paper tissues scrubbed into wet ink areas also provide further useful effects.

Pen and ink work is often combined with various forms of washed in colour. This can either be with coloured inks which are made for the purpose or by watercolour. *Never try and use too many different colours together when you try this.* Warm or cool browns, greys, and bluish-greens will give sufficient variety, particularly when the shadow tones are well modulated.

Brush and wash Brushed on washes can be added to pencil, *Conté* crayon, chalk, ink or charcoal drawings. The effect will vary from material to material. Watery washes will pull out, extend or smudge chalk and charcoal drawings, as will *Conté* crayon if it has been heavily applied and is loose on the surface. Wet ink of course will run. None of

these things in themselves are bad. They need to be experimented with then can be used when the occasion demands.

Water will not, of course, stay on top of grease, and so washes will not combine with greasy crayon or pencil work. This does, however, provide us with a method of preserving paper colour areas or points within a laid on wash. If an area which is going to represent water is first dotted fairly heavily with a fine pointed white greasy crayon on thin piece of candle wax, any watercolour washed over will not cover the greased dotting. If this is done on white paper, the white marks preserved by the grease will suggest the sparkle of reflected light seen on water, when the surrounding paper is made the colour and tone required. This is again something which can only be achieved to one's liking by practise.

The application of a plain wash to an area of a drawing requires an amount of skill, so practise is required. A wash should be applied from across the top of the area to be covered, the paper surface being tilted so the wash can be guided down by the brush. At the beginning of the process the brush should be very full or loaded; however, soon after half the area is covered the brush needs to be dryer so that it can take up the accumulated wash from above and used to guide it into and up to the lower edge of the area to be filled. All is a matter of practice and judgement. The first part of the wash applied with the brush is drawn rapidly across the top of an area, a second brushfull is immediately applied across the paper to key in with the previous brush run, then a third and fourth, and so on. Generally by about the third or fourth stroke a long pool is forming across the paper, so don't tip the paper surface up too much or you will lose control of the wash which may run all over your paper.

Drawing with use of added tone or colour washes is exciting. Because the addition of a wash, generally at half-tone strength to the shadow side of forms, immediately gives a sense of solidity and structure to a sketch. It is also a wonderful help in creating atmosphere and space, The addition of washes creates a mood in us, which either echoes the scene· we have in mind or suggests alternative treatments or alterations. The suggestiveness of washes, or washes interspersed with drawing marks, helps our developing attitude to the scene on which we are working. Little accidents occur, there are hints from the developing shapes of clouds, waves or ships, this is stimulating and awakens our imagination. At times I commence a piece of work by starting with a

wash, either very pale or sometimes very strong. This is a matter of mood and the atmosphere you are after. I then add drawing marks in pencil, pen and ink or crayon depending on the kind of detail or contrast I want.

If a piece of work is going to need a number of washes of tone or colour, then it will probably need to be set aside from time to time so that the wash can dry. Too many washes running into one another creates a mess from which there can be little profit.

Washes can be controlled or altered by the use of blotting paper, and there are many occasions when it is useful to make light areas in heavier ones by blotting out. For example, the suggestion of distant clouds or wave crests. I always have fairly large sheets of blotting paper, about 44 × 56 cm, ready to hand for this purpose.

For the beginner there is a very real danger that he or she may use too much colour, or too many colours, when starting to use wash. Use only one colour at first, that is work in tones of one colour or monochrome. Monochromes of brown, grey, blue or greens are good to start with. Practise using the colour of your choice to strengthen your drawing. You can strengthen first of all by adding a tone to the shadow side of forms. Do this a number of times adding cast shadows and toning down far parts of a scene with pale washes. Once you find you are fairly successful at strengthening a drawing then you can try different monochrome schemes. After that, you could try tones of two colours. At this stage be careful your colour is not too strong. The range of colour paints you can buy divides into what we recognise as warm and cool colours. Yellow, orange and red give sensations of warmth. Green, blue and purple or violet give sensations of coolness. When you first venture into colour give careful thought to this warmth and coolness. Try pale warm colours against pale cool colours. Observe how they appear to affect one another. In most cases they will not harmonise, rather they may be seen to fight a bit, and be 'pushing away' from each other. Try monochrome washes of cool colour on a drawing with small additions of a warm colour. Then reverse the process. In this way you will come to understand the power of colour because you will appreciate what happens when warm colour is contrasted with cool colour. If you want two edges of shapes to knit together in a drawing, then, in general, if coloured, both will need to be warm or both cool. They will harmonise. If, however, you want one area to lift away from the other, then use a slight contrast by making one tone warmish and the other coolish. A useful example of this to keep in mind is where you have sky and sea seemingly touching on a clear day. If you make the sky above the sea at the horizon, slightly warmish, and the sea below slightly coolish, then it will appear that the sky is above the sea, although they apparently touch!

What is warm enough or cool enough in a colour is a matter of experience, but also it is a matter of personal habits in colour usage. What is certain is that too many different strong colours together in the beginning will ruin a drawing, and spoil the simple conception of a scene.

Gouache This means working in opaque colour or body colour. When you are applying washes with watercolour it is assumed that you are allowing the white paper to shine through; the washes are thin and transparent. If your paint is thickish, or it obliterates the colour of your paper, and is diluted with water or gum, then you are working in gouache. Quite often we move into gouache without realising it. If white paint, in watercolours, is added to all the other colours that you use then you are actually using gouache. The addition of white will make all the colours opaque and give them body. Particularly so if only small amounts of water are used. It is not unusual for a watercolour painting to turn into a gouache as we struggle to complete it! It need be none the worse for that.

Gouache, however, is a method in its own right and we can use it from the beginning. As it is opaque, it can be used to make lines or drawing marks with a brush. It can also be easily overworked, one tone or colour obliterating another with ease, especially when the first is dry. It can be bought in tubes under the names of designers or gouache colour, and it is possible to purchase trial sets so that you may discover the range of colours and tones available. Poster colours, sold in pots, are really another form of opaque colour that can be diluted with water.

Gouache can be handled very freely because one can always over-paint, whereas for watercolour effects you should over-paint very little. Tone and coloured papers can be used. Drying gouache drawn onto coloured paper gives an effect of great charm. Gouache colour has a tinted or grey appearance, but if warm tones are applied to cool toned paper, or the reverse, the result can be powerful and pleasing.

Charcoal Charcoal is manufactured by charring or burning special woods, the process is really one of partial combustion which changes the nature of the wood so that it is blackened and inclined to crumble. It can be used up very rapidly and breaks easily. Many prefer its soft quality to chalk. If used on coloured papers, light areas may be heightened with white chalk. It will combine with other drawing materials but requires fixing first. I find with charcoal that I need a large amount of fixative which is applied in layers as the work proceeds. Each layer must be allowed to dry before work continues. Charcoal is renowned for its velvety blacks. It is a material which I have never used much out of doors, but have kept as largely a studio material.

Charcoal may be combined with soft pencil, pen and ink, chalks and washes of colour provided fixing takes place at appropriate moments.

Chalks Chalks are not so popular as they once were. Chalk is a product of soft rock formations. It is generally thought of as white, but it can be quarried as dark grey to black or earth red. The latter may be called sanguine or blood-like.

Red chalk was popular as a drawing material in the seventeenth, eighteenth and nineteenth centuries. Because of its luminosity, its palest tones are radiant, and even a poor red chalk drawing can look attractive. It is, therefore, a useful material to try at times because it does boost a flagging confidence and morale.

There are also proprietary brands of manufactured chalks – the blackboard chalks. They can be obtained in a range of colours, but all are 'chalky' or in pale tints. They can be effective on coloured papers. White chalk can be used with charcoal for heightening, but may also be used on dried wash studies or watercolours. It can be combined with pen and ink work. For storage, chalk work requires fixing.

Pastels Pastels are manufactured in the form of sticks. They may be soft, medium or hard. They are made from finely ground pigments mixed with a filler such as chalk or clay and then bound into the stick-like composition with certain gums. The expensive variety have a greater brilliance. They need to be used on a good quality Ingres type paper which will display their velvety brilliance. They are fragile and crumble easily. It may be felt they require fixing, in which case fix every layer down except the final one. This is because pastel work does deteriorate and loses brilliance from over zealous fixing. It is really best preserved behind glass. Pastel pigments themselves are permanent and do not change in appearance with time.

Heightening Heavy pencil drawing on toned paper, charcoal or *Conté* drawings, pen and ink work, and drawings built up with tone washes can all be heightened. That is they can all have highlights or lights touched in with white pencil, white chalk, white ink or white paint, or gouache. Heightening need not always be white. Surfaces and contours can be picked out in any other light colour. Heightening can be modified and serve to make alterations by covering up unwanted portions of drawings. Its primary use is to advance the near portions or contours of forms optically, at the same time as it enhances the appearance of a drawing by providing a sparkle. It can be used to give the effect of reflected lights in seascapes. Once dry, it can be hatched over with drawing techniques or toned down with a wash and then brought back again in a second attempt later. It is very much part of multiple drawing techniques, and carries the assurance that even the worst drawing is never quite lost.

Pencil erasers These are formed gums used to erase unwanted parts of pencil or *Conté* drawings. With the increase of time it will be found that they are not used a great deal but rubbing out is a form of reassurance which we all need from time to time.

The putty rubber type which can be kneaded into shapes is probably the most useful kind. Soft pencil, *Conté*, chalk and charcoal work can be stippled with it, the stippling then drawn into.

All forms of erasure movements can be used as part of drawing technique, and readers will find that, in time, they come to adopt this method. For example, erasure with a moulded point of a putty rubber across a toned pencil area will create white lines. This is a drawing method. A heavy contour crossed with white passages made by a putty rubber is equally so. The white lines 'drawn' by the eraser can then be echoed with drawing markings and so on, erasure alternating with drawn marks.

Practical Preparation

Finding a subject

Outdoors Unless you have a special request, chosing a subject and the form of composition for it is probably going to be a matter of mood and intuition. Even having chosen and started work you may find that the subject does not hold the interest you expected and so a new one has to be found. Another, and happy alternative, is that you are so successful that you start planning for a series of drawings based on different aspects of the same subject. So be flexible in your approach, and not too disheartened if all does not immediately go well.

Preparing to draw

The following is an example of the sort of thing that could happen when you have gone out sketching.

Standing on a beach looking about for subject matter you see in one direction a small harbour enclosed by a wall, with a lighthouse, harbour wall and assorted boats, and in the other direction a wide expanse of choppy sea, with sailing boats racing under a cloudy sky. To make a choice you will probably have a discussion with yourself which might go something like this:
First view: The harbour wall would give me some strong horizontal lines and would make an interesting base, and foil, for all the masts of the boats and the upright lines of the lighthouse. The lighthouse is catching the sunlight and making a bright reflection with the harbour wall in the sea, and that reflection could be may main feature.
Second view: I do like the silhouette of the sailboat shapes against the sea. These could be my main interest contrasting with the lines of the clouds and waves.

Looking from one to the other you might then decide on the second, because you feel you would enjoy tackling the movement suggested by waves and clouds. However, feeling differently on another occasion, the harbour and lighthouse could win.

I find that a viewfinder cut from a stout piece of card is a great help in subject selection. Cut a rectangular opening from the centre of a small sheet of card, in the same proportion as the paper on which you intend to work. Any two rectangles which share the same diagonal are in the same proportion (1). So if you draw a diagonal on the sheet of paper on which you are intending to work, you can then discover the dimensions of a small rectangle suitable for a viewfinder, and in proportion to your paper. One dimension of the opening does not need to be more than 5 to 7 cm; in fact, if you hold it fairly near your eyes it may be smaller. You use it by moving it slowly across a scene and considering the subjects it presents.

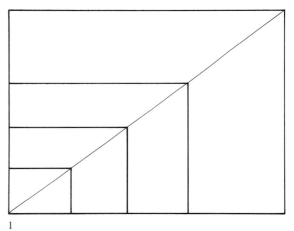

1

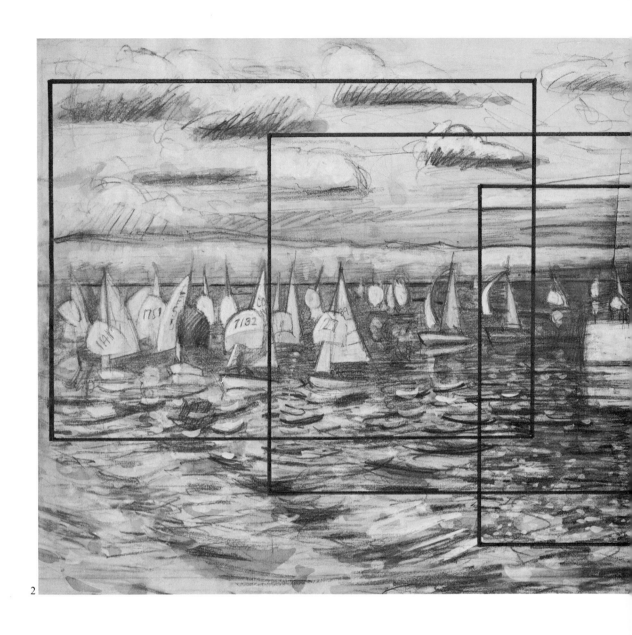

2

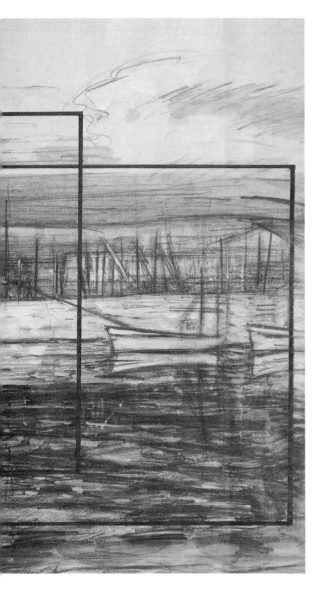

Once you have chosen your subject you may still wish to use the viewfinder as your drawing progresses. You can check on main lines and proportions as you go. I have drawn three rectangles over my drawing of sail boats and lighthouse as examples of how compositions may be found with a viewfinder (2).

Working at home or in the studio The alternative to working direct from nature is working at home from sketch-book studies or photographs, or other forms of illustrations, and using one's imagination. It is not always convenient to make extensive use of

mixed materials out of doors, and in any case a good proportion of one's output should be imaginative. By 'imaginative' I do not mean 'fictitious'. It is in this regard that sketch-book studies are so valuable, and in each of the following sections of the book I have included studies of this type.

Starting a drawing

How do we do justice to our choice? What do we look for, and how do we approach the paper?

Let's take the lighthouse subject. The harbour wall give strong horizontal lines. Firstly mark off across the paper quite lightly, one or two of the general directions of the wall lines (3). You may have used a viewfinder and have decided you would like the wall slightly above halfway on the paper surface. Then lightly draw directional lines to the left to establish the horizon, and then take the horizon line back to the right above the wall so that you know where the horizon is right across the drawing. You could check with a ruler that the horizon is equidistant from the top of the paper and, if no one is looking, you might even re-establish the horizon line, ruling ever so lightly! With much practise through the years I can now guess a straight line in sketching, but I have rulers with my equipment and use them when I feel like it. It is important at times to establish a truth like the horizon being horizontal. Later, freehand drawing will eclipse the light construction lines but in the beginning you will have the security of knowing that certain things are correct and can be relied on.

You can now go on working on your drawing, re-checking and re-establishing the harbour wall proportions, and then drawing the uprights for the lighthouse sides, and the directions of the boats' masts. Check all the spaces between these lines and try and get the spacing and proportions correct. Count the number of masts; that's a good way to achieve correct proportions – are there seven or seventy-seven? It clearly makes a difference. I do a lot of counting in this way when I am drawing. At least in the beginning. Then establish the direc..on of the wave lines on the water. A good way to check this, or any oblique directions in a scene, is to hold up your pencil against the direction and then see if you can estimate the angle it is making against an imaginary perpendicular or horizontal. Do this by asking yourself how near it is to 45°. This should give you a better idea than just guessing. Then using more lines, draw the directions for the base of the clouds across the paper.

17

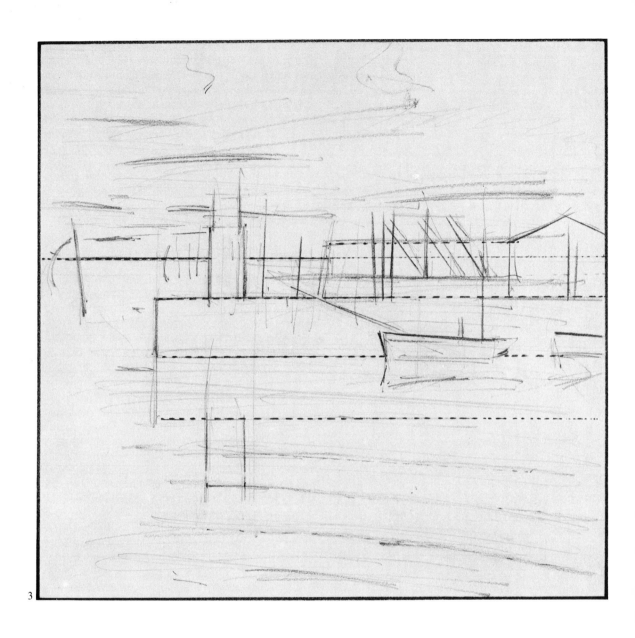

You have now roughed in your scene using lines. Incidentally, the order I used is not crucial; just make sure the horizon line is drawn fairly early on. The horizon in this case is one of the main compositional lines cutting the paper and the drawing in two. In the early stages of a drawing there must be a directness of approach using chosen main lines to indicate a constructional summary. In any sketch (small or large) of a scene we must try to achieve this total architecture in the first few minutes. It is easier to do this on a small scale first of all.

Had we chosen the other subject possibility, the approach would still be much the same; the horizon established early and, as we were considering the silhouettes of sail boats against the water, kept reasonably near the top of the paper. Then we would make the constructional lines for wave crests and cloud formations. Finally we would observe the sail boats, count them, and see how many are near, far, or in the middle distance, and establish directional lines for them, checking spaces between and trying to get proportions correct. Of course the sail boats are moving so you can take liberties with spacing and have fun. I generally watch such a happening for a few seconds and decide on the form of cluster or separation I like.

In the following stages, drawings become more individual in character, although of course individuality is present even in the first compositional lines. However, it is during the building up stages of a drawing that individual notions on light and shade, atmosphere, depth and space, and movement begin to assert themselves. In this process we emphasise and select according to our feelings.

You make your first contact with the subject using constructional lines and at the same time your awareness of it deepens. If you have stayed with the subject it is because your eye and brain are delighted by it'. With the constructional lines indicated you can afford to pause and just look at your subject for a while. By doing this you discover more about its visual qualities, that is its tonalities, textures, proportions and so on.

If you are really quite new to drawing then perhaps looking for contrasts is your next step. Notice how the water behind the lighthouse appears darker and shows it up, and similarly how the water tone next to the reflections appears darker (2). If you look for light against dark like this you will begin to see it everywhere in your subject. It will help if you half close your eyes so that small details

are lost and you can just see the broad patterns of light and shade. Attempt to represent this in pencil, perhaps using a softer lead. Finally you might try adding a tone of watercolour. Whatever you do, make sure that all the light areas are left uncovered. Once they are toned down your drawing will be that much less dynamic. Always preserve light areas is a good rule to remember. If you have never attempted drawing out of doors before, I suggest you keep all the first stages light in tone, and then go right through the process for a second or even third time to establish stronger middle and dark tones. For those more practised, the shadow and toned surfaces can be built up at the same time as detail is added.

In the building-up stage, I suggest we always look for the exceptional, something out of the ordinary, that produces a noticeable visual effect. This *exceptional something* might be a strong bar of light underneath dark clouds at the horizon, spray breaking high over rocks, or the unusual silhouette shape of a moored ship. In the example which we have just used it might well be the reflection of the lighthouse and harbour wall. This *exceptional something* has to become manifest in the drawing and made significant. We should not really try to make an exact imitation when we draw, even if that were possible; rather we should be looking for an *exceptional visual something* to form a theme. If we succeed, our drawing will make a strong statement and be arresting and attractive as well.

During the building-up stages, keep moving all over the drawing if you can, putting touches, edges or small areas in at one place, and then switching to do something in another part of the drawing. In this way the drawing moves along as a whole and your search for balance – balancing one part of the drawing with another – moves through many stages until the finished drawing emerges. It may be that you do have to work on one part of a drawing for a little time, perhaps to make a correction to a shape or proportion. If this happens, make sure that afterwards you stand back from the drawing and try and discover if this necessary correction has put the drawing out of balance or pushed a detail out of focus. In either case *don't leave the drawing until its balance has been restored or its unity is beyond doubt,* and don't let any interruptions take you away if you are involved in this type of correction.

More about lines

When you draw a line on a blank sheet of paper, your eyes will travel along it and *read it*. Thus a few lines together on a piece of paper will create a sense of activity. Dots, marks or points can have the same visual effect when they are lined up. In fact, when I am not absolutely sure that I do want a line in a particular place I start with dots and let it become a line later, for dots made fairly close together will serve as lines.

Lines are drawing, and the general meaning of a drawing will be fixed in its first few lines. So the way you handle them, right from the beginning of a drawing, is important, even if no one else can understand what you are doing.

To draw with lines you have to look at your subject in a special way. You must forget most of the detail and look at the edges of the larger shapes. Your first lines may not become clear in context to others until you have added to them (4), so your first lines have a message only for you.

Starting lines make a skeleton composition and are bound together by the use of more and more lines. Base lines are made more meaningful by additions. A base starting line can be turned into the mast and rigging of a ship, or rocks along a river's edge. The first base lines give the essentials of placing and direction.

I said earlier that lines create activity by causing the eye to run along them. In fact, they impel us to transfer our attention from one end to the other. All sorts of lines are used in advertising and warning notices because they can do this. In drawing we use them not only to create compositions but also to create movement.

A line drawn across the paper as the horizon, creates little movement in itself, and other lines placed parallel to it harmonise and suggest tranquility (4a). Place other lines at oblique angles to them and you have movement (4b). The more lines and angles that are added create even more movement. If this were uncontrolled there would be chaos in the end. What we have to do therefore, is limit the total number of different angles or directions in a drawing.

In actual practice when drawing outdoors, this limiting is done for us. In 4c I have taken the line diagram a stage further, and what is suggested is a rocky coast. Here you can see the number of new directions is limited by the distant mountain and rock shapes. Also I have demonstrated how a number of line angles have been found to repeat.

The repetitions are in dotted lines. This means that the line composition has not only been simplified but also harmonies within different angles have been found. This sort of selection from nature is important if you wish to make a powerful and intelligible drawing.

One thing more to know about lines is that they really are a convention determined by the fact that we use a pointed tool with which to make them. When we draw a mountain shape silhouetted against the sky, we are stating that at these edges we can see no more mountain and the sky is beginning. This is fine, but we should also realise that there is no line round the mountain and in fact there are no lines round anything we see. We see edges which we can draw as lines because one shape in nature is always lighter or darker than the one next to it – because of natural light or lighting. This is useful knowledge because in certain situations it is good to know on what shapes your lines should be made to sit, and what toning down is required, in relation to them, to make one shape go behind another or stand out from the next one. To show what I mean I have drawn the stems of four moored boats (5). The outline of the stem of the top boat has been made from the water tone, so the light shape of the boat is suggested by the dark water tone. In the boat below, the reverse of this process has been used, the shape of the boat is suggested by the dark tone of the boat, and the water has been left light in a halo effect. When shape has to be distinguished we must consider tone values in this way. As a drawing is built up it becomes more and more important that we can see the tonal differences between shapes. When we use outlines we have to make sure they 'sit' on the right shapes.

Composition

A little more about this word. In the broadest sense, the whole of this book is about composition. When we are looking at the contents of a river or sea scene we are considering composition. Composition is concerned with the nature or proportion of the contents. So that whatever you look at is a possible composition. The lighthouse subject mentioned earlier is a composition; the sail-boat subject outside the harbour is another. You may have found yet another subject combining the lighthouse and some of the sail-boats. When I described the use of a viewfinder I was really describing how you might find compositions. The chief thing to remember is

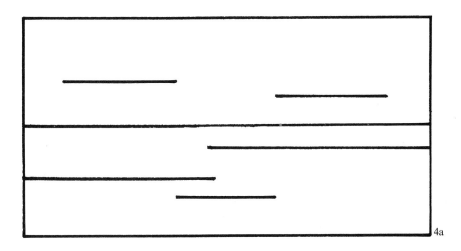

4a

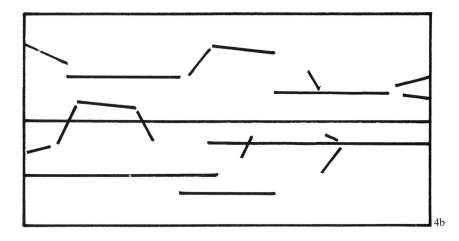

4b

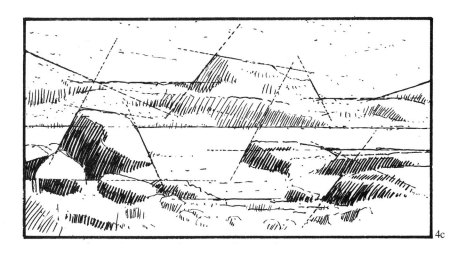

4c

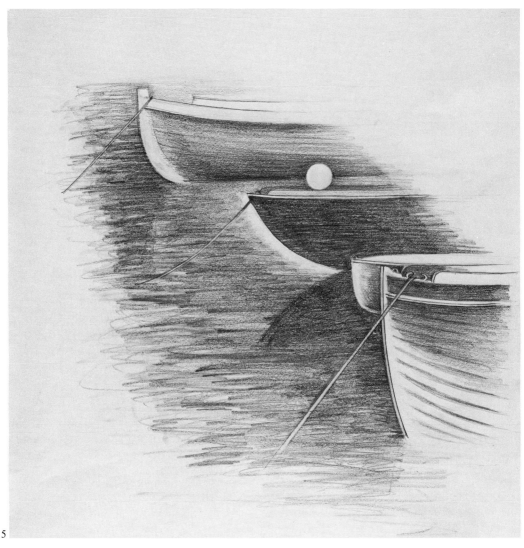

5

that the content of a scene must fit into the proportion of your paper or sketch-book sheet. Any images you may see – boats, ships, docks or cliffs, for example – will make a composition if the frame through which you view them is in proportion to your working surface. This is why the viewfinder is so good in the beginning.

Until you become more experienced at estimating the proportions of a scene in relation to your drawing paper, a viewfinder will be an invaluable tool. You will find that it will not be too long before you can rapidly guess how the scene will fill your paper. The final happy surprise will be on the day you discover your composition works even if the content you have planned for it do not quite work

out as foreseen. Some object has had to be cut off, or more of it included than planned. Of course I do not suggest that if you are doing a ship's portrait you only do half of it! Conventional portraiture is the only exception to what I have said.

Don't think that composition is something very special and separate from your drawing, and don't confuse it with success. You will compose naturally if you enjoy drawing what is in front of you, and that way you will be successful.

In the following sections of the book I look at how to draw the sea and water, the sky and clouds, boats and ships, but at the same time I treat all these parts of sea subjects as ingredients of pictorial composition.

The Sea and River

The sea and water as a flat plane

The sea to many of us is as exciting as mountain ranges, the enormous unfathomed depths corresponding to great peaks, the innumerable patterns of broken water and wave formations to varying rock faces, ridges and valleys.

However, the sea, or river and harbour water, is essentially flat when thought of from a drawing point of view. The first concept must be one of a flat plane stretching away to the horizon (6) or some other limit, a harbour wall or river bank. This plane is the surface of the sea. If the sea is wild and turbulent, with waves built up by tide or wind, then we must consider that the waves are built on top of this imaginary flat plane. This concept is the only means by which we can control the perspective of water and wave formations. When the sea is calm it does not in itself present an obvious image; and rather it is a stage on and over which events occur. With a calm sea you must make compositions from shipping and boats and also make good use of cloud formations.

L S LOWRY shows a perfect understanding of the essential flatness of the sea (7). The stillness is demonstrated by the uprightness of the masts of the little flotilla of boats at anchor. The pencil marks on the sea in the foreground show how it is lightly lapping the beach, and intensifies the mood of general quietness felt throughout. The scene is empty of people, there is no one on the boats or by the lighthouse. It may be very early morning, we cannot be sure. What is most moving for me, and why I remember the drawing so well, is because of the economy of means by which the flatness of the sea is invoked. The boats are marked as little more than pencil blobs sitting on something between sky and wavy sea edge, and the sea is confirmed by few horizontal strokes. The most elaborate drawing could not be more successful than this.

Two sketches demonstrate how different materials may be used to draw the sea's flatness with textural interest. In the first I used a 6B pencil and a fine point felt tip pen (8). I was standing on a breakwater which I left as bare paper, the sea was calm although there was a definite swell running with long thin wave crests gently rolling in. The waves had a slight but definite lift. It was a sunny afternoon and it was extremely difficult to see the boats because of the strong sunlight being reflected off the water. The sky I left almost clear, just lightly indicating clouds by slight lines and points in felt pen. The points somehow helped the effect of bright light. The sky and the sea were both sketched in with a crayon-like effect in 6B pencil. I completed the wave lines and boats with felt tipped pen. Like the Lowry, the boats needed only to be blobs; the waves I worked on longer, pulling their ends out into the points which were then merged back into the general surface. This drawing took fifteen minutes.

The second sketch (9) took three quarters of an hour. I used HB to 2B charcoal pencils. The horizontal quality of the sea is indicated in long HB pencil lines more in the foreground than in the distance. I then indicated the boats and more water texture with a B pencil. It was late afternoon, the sea fairly calm but with innumerable ripples caused by a 'mackerel' breeze – a breeze that favours mackerel fishing, and which ruffles the sea surface. I worked intensely for what must have been half an hour with a 2B pencil, building up a darker and darker sea for the foreground. Whilst doing this I jabbed the pencil down to make points; this was to give the sparkle

23

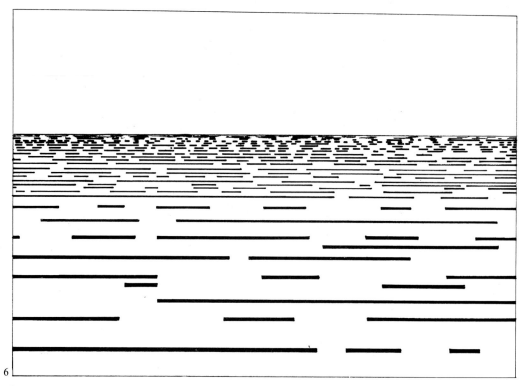

6

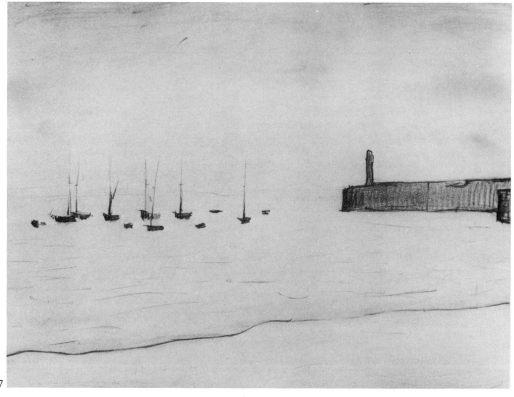

7

24

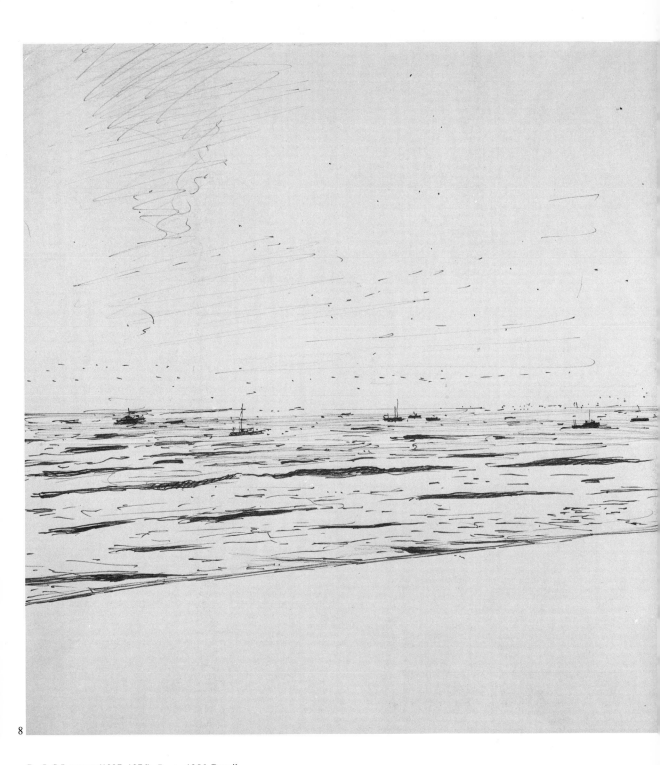

8

7 L S LOWRY (1887–1976), *Boats*, 1956. Pencil
(305 mm × 355 mm)
The City of Salford Art Gallery by courtesy of Mrs Carol Danes

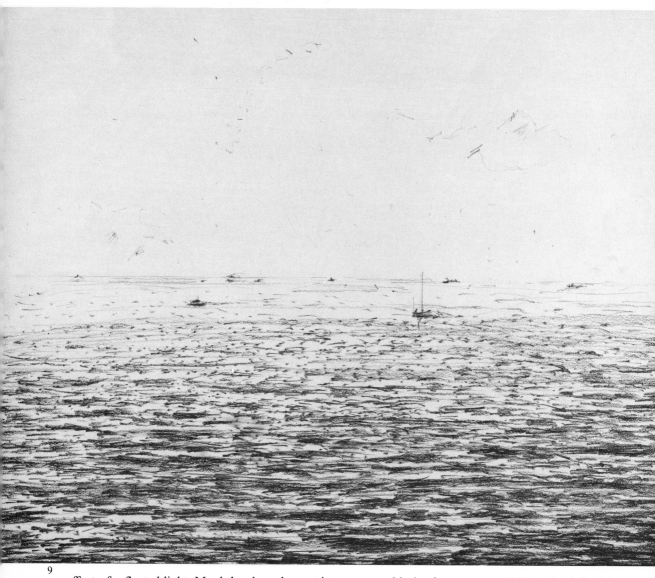

9

effect of reflected light. Much hard work went into drawing the sea, the aim being to leave as little white paper as possible; the small amount left being scattered in as many minute areas as possible to aid the sparkle effect.

Waves

It takes only two waves to make a seascape
Winslow Homer

Once the sea is troubled by wind or tide, the bow wave of a ship, or by being dashed against rocks or a spit of land, then its flat surface is broken up into many kinds of movement. A tide is the daily ebb and flow of the sea, which takes place twice daily and it can force water over banks or strands, and can form tide-rips and currents in channels. Ridges can also be formed on the surface of the sea by the tide and by the wind. These are surges of water pushed across its surface in the form of waves (10). A strong swell can rise and form waves. Waves form into lines and will only be broken up when forced against sea walls, banks, rocks or the margins of beaches. One exception is that swells at sea can be cut by strong winds and the crests dissolved into spray. The wave breaking onto the shore, particularly against large

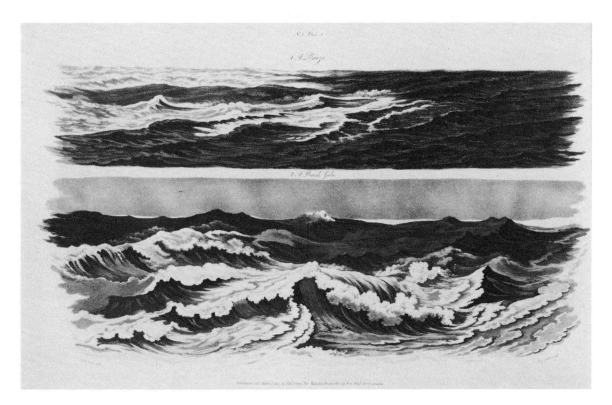

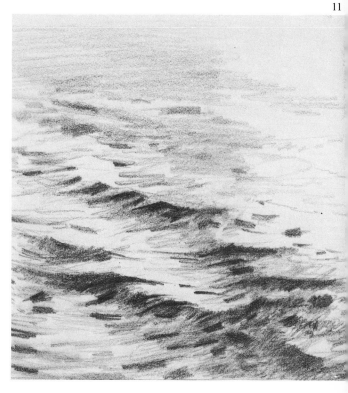

10 JOHN THOMAS SERRES (1759–1825), *A Breeze* and *A Brisk Gale*. Acquatint by J C Stafford (107 mm × 430 mm – 150 mm × 430 mm)
Courtesy of the Trustees of the British Museum, London

rocks or against breakwaters, is very exciting because of the fountains of spray that are thrown high up into the air.

A powerful swell can appear a formidable sight, particularly from a small boat. Heavy black marks cannot be avoided in drawing this type of water as one side of the swell will always be in shadow (11). For this drawing I used a *Black Prince* pencil which gives a good heavy mark. When I made the drawing, a shaft of strong sunlight was playing on the sea from the right.

A swell rises and falls in a ridge formation and has a bulging, heaving quality. The second effect I drew in a harbour, and this swell had been caused by the passing of a large vessel (12). For this I used *Conté* pencil and ink wash. Again the heavy markings are on the shadow sides of the swell ridges. The permanent mooring buoys were tipping over with the rising and falling water. The wash is in ink diluted with water, it was applied three times, being darker each time. I finally used the *Conté* pencil to

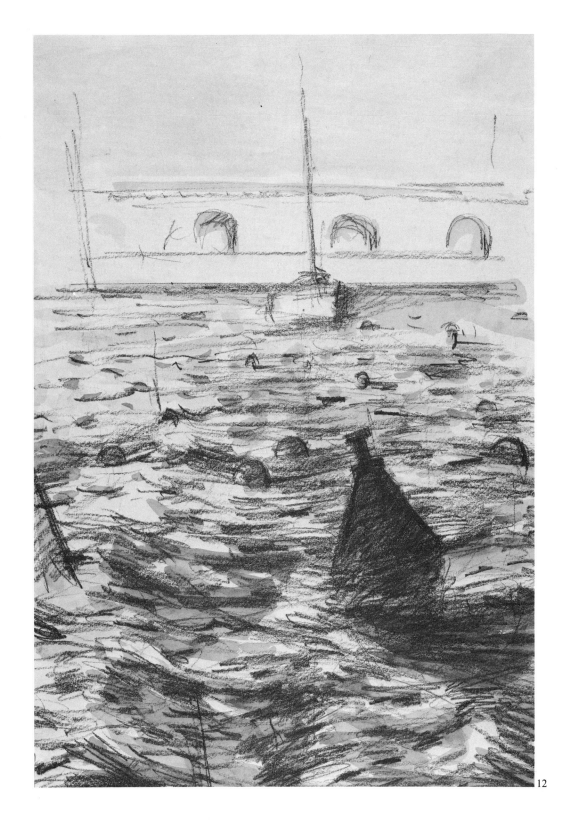

12

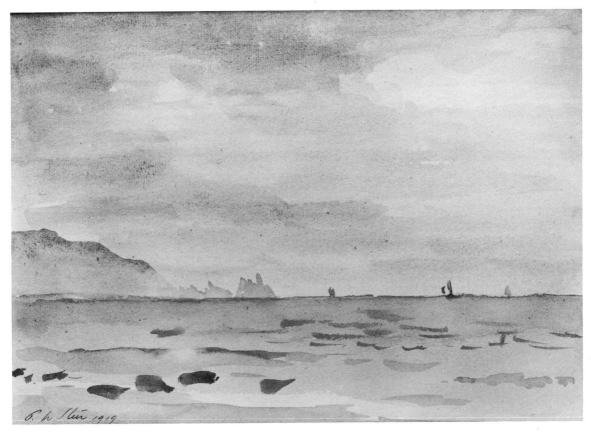

13　P Wilson Steer (1860–1942), *A Grey Day, Dover Harbour*. Watercolour (245 mm × 345 mm)
Victoria and Albert Museum, London

get the short sharp marks I wanted to give the effect of the water movement.

Wilson Steer's watercolour drawing *A Grey Day* (13) shows a fairly calm sea but with a noticeable swell running, this has been indicated with round brush strokes in a slightly concave movement. There must have been an ebb tide and a light breeze because no cresting waves break onto the beach. There is just a small portion of white paper left in the foreground to suggest a little foam left by the pull back of the sea. The sailing ships on the horizon bend slightly to the breeze and this movement is echoed by the rocky headland. The sky has been kept flat and expressionless in keeping with a grey day. Notice the division of the drawing into sea and sky. The sea occupies one third of the paper and the sky two thirds. The horizon divides the drawing in a most interesting way, and the one-third two-third proportional relationship will always give this result. An equally interesting proportional relationship would be the complete reversal of this, the sky occupying one third of the paper and the sea two thirds.

Waves have marked crests as they approach the shore, often with quite well defined lips and edges, and are very beautiful forms to draw. They must be thought of as forms running in perspective lines on the sea's surface. Drawings 14, 15 and 16 show waves drawn in three different materials. In the first (14) waves are approaching the shore and building up into large ridges. The two nearest rows are very concave as they begin to curl over to crash onto the beach. I made the greatest contrast of tone between the top of this concavity, which was in shadow, and the sharp lip of foam at its crest. The foam shapes I left as white paper. All the tone used is made with the hatching of many fine felt pen strokes. Some crests were more marked than others, which adds interest to the drawing. A previous wave which had broken on the shore had left a lacy froth which I drew with many interlacing curved lines. This same

29

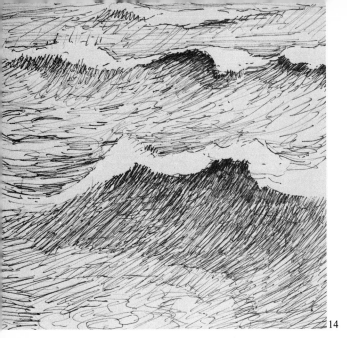

14

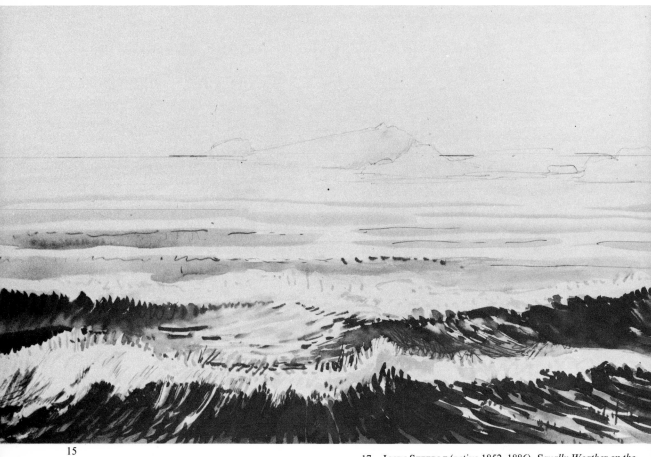

15

17 JOHN STEEPLE (active 1852–1886), *Squally Weather on the Welsh Coast*. Watercolour drawing (197 mm × 400 mm) Victoria and Albert Museum, London

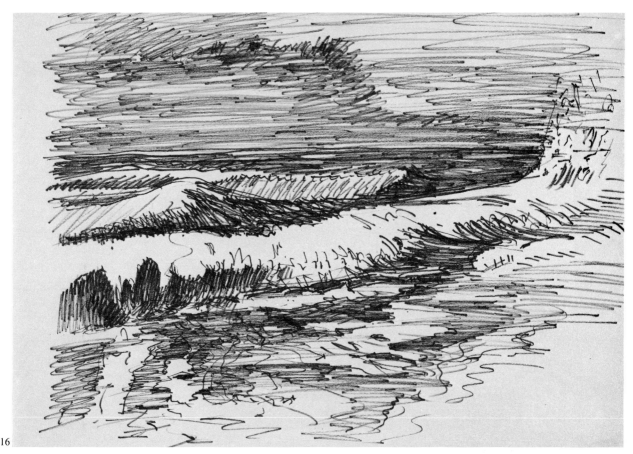

16

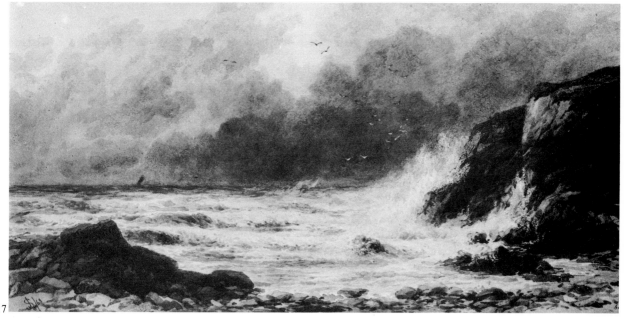

17

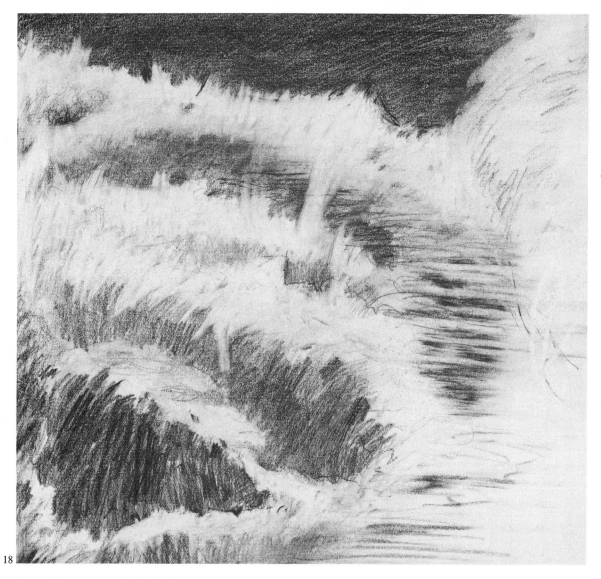

18

lacy effect occurs behind the nearest wave crest where a previous wave had broken in the shallows before the shore line. The drawing took about fifteen minutes.

Another drawing of wave crests (15) took rather longer, about three quarters of an hour. I started this drawing with a 2B pencil but later built it up with ink and a No. 6 round brush. I diluted the ink with water at first, but later, working on the concavities of the waves, I used it neat. It is important when drawing to be able to preserve the white paper; in all three of these drawings this was relevant.

The last of the three wave studies (16) was drawn with a heavy felt marker pen and done very rapidly. It was drawn in a sketch-book and I wanted to get the effect of the waves breaking on the shore late at night. I tried to make the white paper, left for the wave crests, appear as luminious as possible by toning in the night sky quite heavily. Again the darkest part of the wave shadow came under the near edge of foam.

Waves moving inshore are finally broken against obstacles: rocks, steep beaches, breakwaters, piers and harbour walls. They approach with great force and power and, depending on the obstacle, the

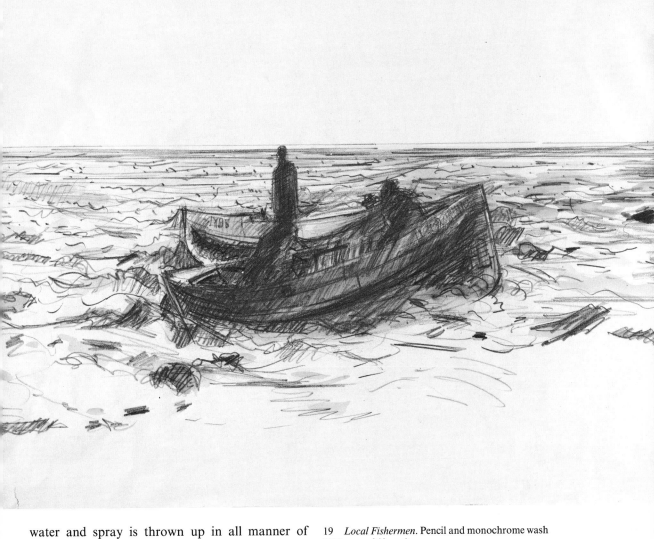

water and spray is thrown up in all manner of shapes.

JOHN STEEPLE'S watercolour drawing of waves smashing into rocks on the Welsh coast gives a very fine and stirring account of waves breaking (17). The waves smashing up the cliffs have been given a magnificent pictorial setting by a framing of rocks, cloud banks and dark forbidding headlands. A powerful romantic view that would have pleased his Victorian patrons and would still give pleasure today. All the detail has been arranged for pictorial effect but is none the worse for that, for there is nothing out of place or scale and one feels it would

19 *Local Fishermen*. Pencil and monochrome wash (480 mm × 840 mm)

be possible to discover the exact spot from which the scene was viewed.

It is worth attempting a pencil drawing of waves breaking over rocks. It requires a great deal of labour, but is most satisfying because it assures practice with a range of different pencil leads. In my drawing I used HB, 2B, 4B and 6B pencils (18). Again one aim was to preserve the light, which in this case was the water foaming and breaking over

the rocks. I used a pencil eraser on a number of occasions, cutting small wedge shaped pieces off a large one. The wedge ends work well to scour out the splintering shapes of the breaking surf. I used lighter pencils first and finished with the 6B. The sea water in this instance was forced between ridges of rock which it frothed and boiled over. I kept stressing the bright water by darkening the rocks and repeatedly clearing out water shapes with pieces of eraser.

A fairly calm sea may be covered with wavelets with enough elevation to reflect light and create a sparkling effect. This detail of a drawing made of two club boats out fishing shows this form of surface (19). I drew the shadow side of each wavelet with a top and bottom edge and left the white paper to provide the sparkling light. The further wavelets I just drew with dashes and points. I also used a half-tone monochrome wash with the pencil work, which was with a 6B.

A sea surface in charcoal is shown in 20. It was drawn to represent the feeling of vastness and emptiness that occurs when out to sea in a small boat. On the horizon, which I have kept high for dramatic effect, a fishing trawler dips and partly disappears from view. Anyone who has been in this situation will know how cut off one can feel even though another craft is near, and this is what I have tried to convey. I have also tried to suggest the bulging tension of a strong swell. To the spectator, low to the water, even a trough in a swell can limit the extent of their horizon and only a large vessel nearby could be seen.

Headlands, cliffs and rocks

Headlands, cliffs or rock formations are quite often famous visual features, and famous or not they will be used by inshore sailors as navigation marks. Two such features, seen in a line from sea, will give what a sailor calls a cross bearing. Headlands, cliffs and rocks are all part of the shoreline and offer a great variety of features. Shoreline scenery may change every fifty or a hundred miles or so; cliffs giving way to bays, bays to beaches, or rocks and river mouths, and then there are cliffs again but with different geological features from the previous ones. Such variety provides countless happy havens for the artist.

The sea in sight from the shoreline is known as the *offing*, and this region off shore is full of interest for the artist, for it is here that the activities of the yachtsman and small boat enthusiast take place. In the drawing, *Passing the Headland*, I have shown two small boats making a safe passage round some tall cliffs (21). I started this drawing in 6B pencil, drawing in the cliff top shape in front of my feet and then adding lines for the direction of the sea. There was quite a fast current. I then put points of candle wax where I could see the sea sparkling and after that built up the drawing with light tone washes. I used black ink for the headland. At the end I went back to pencil and restated the current direction, at the same time drawing in more shadow on the boats. I think this drawing shows how interesting visual effects can be if one is prepared to take a chance and not consider composition too conventionally.

The CONSTABLE drawing *Portland Island*, shows boats in the offing by a headland (22). This drawing is in pencil supported by a wash. It is formed on an arrangement of compositional lines which are very popular with seascape artists (23). The horizon is nearer the top of the paper than the bottom and a long curving line takes the edge of the beach from the foreground round to the point of the headland which is nearing the horizon. These two lines divide the paper into three unequal but balancing areas, the beach line taking the eye into the drawing, and on to the main feature which is, in this case, the headland. The drawing is animated by the boats, three figures in the middle distance on the beach and the dark pencil markings for the shallow water in the foreground.

SAMUEL PALMER made this coastal sketch in Cornwall (24) and it is drawn in charcoal. The medium is well controlled, the nearest rock formations being built up firmly by dark strokes in the shadow planes, rocks in the middle distance being in a lighter tone, and the headland in the distance kept very faint. This is a straightforward sketch-book study of great merit.

I enjoy making rock studies; they really are an opportunity for basic drawing practice. These drawings were made in my sketch-book in pen and black ink (25). Do not be deterred from drawing in pen and ink. Make sure you start quite lightly, perhaps just with spaced out points, and with eyes half closed make sure you can see where the light areas are on the rocks. Then gradually build up the

20 *The Sea*, Charcoal (840 mm × 590 mm)

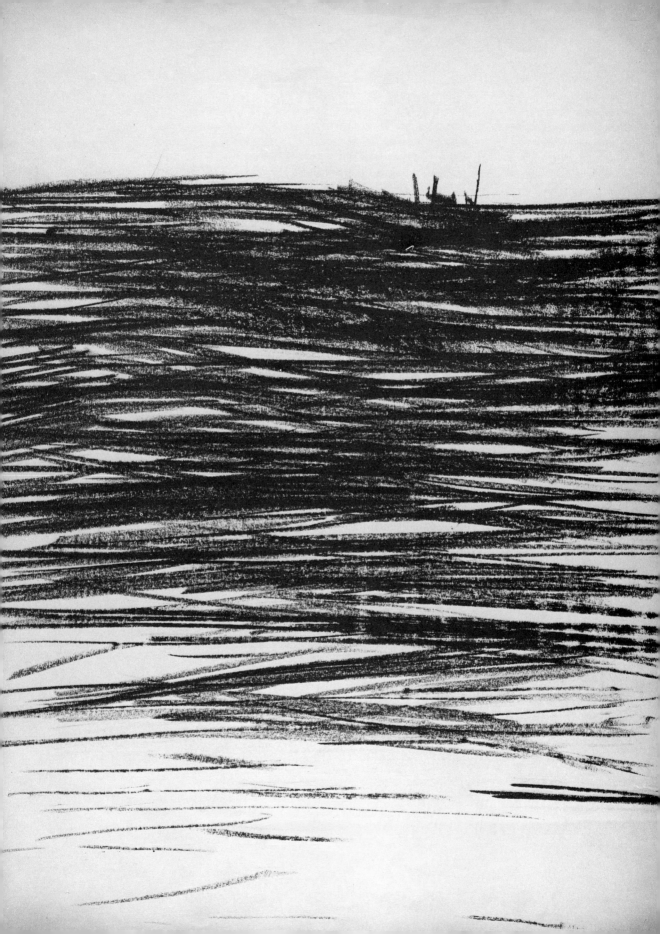

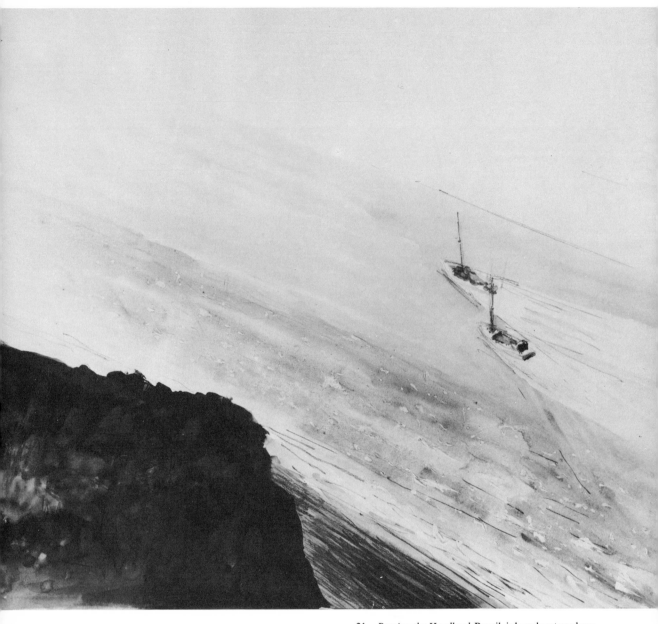

21 *Passing the Headland.* Pencil, ink and watercolour
(525 mm × 672 mm)

22 JOHN CONSTABLE (1776–1837), *Portland Island; Coast
with a Stretch of Shore.* Pencil, watercolour (115 mm × 181 mm)
Victoria and Albert Museum, London

shadow planes, and every so often smudge the ink marks together with a wet finger tip or brush. Cross-hatch as much as you like, and in certain areas taking this nearly as far as having a solid black. If you can sit quietly somewhere and do this you will learn what joy there is in modelling a drawing. Of course other drawing materials can be used but sooner or later you should attempt pen and ink work.

One of the most striking coastal rock studies that I know is WINSLOW HOMER's study of a breaking wave and the sea seen through rocks (26). It represents a part of the coast of Maine not far from his studio. Homer's home and studio were almost completely surrounded by the sea, for which he had such a passionate attachment that he made it a part of his life. He was able to observe and draw the sea without going outside. He had a profound knowledge of forming waves, rough and calm water, flying spray and surf and developed a great skill at creating their likeness on paper. He has left a large number of sea pieces, any one of which would reward study.

This watercolour drawing is haunting and strange because the aperture in the rocks is such an unusual natural feature. We have to be able to recognise a good view when we see it, and that is just what Homer has done. Did he enlarge on what he saw? We cannot be sure. He may have crouched low to get this view, but whatever was done technically was a justifiable distortion to give the framed wave and the surrounding dark and sombre rocks a greater dramatic impact.

Although this is a powerful drawing of rocks it is also a delightfully clever rendering of a wave. It is as if Homer is allowing us to see something happening which is quite private to him. He catches a wave crest just before it starts to break up into spray, and we are able to study how he uses half tone and darker tone to draw the solid wedge shape of water that is being pushed up. This is a drawing from which any seascape artist will always be able to learn.

Often seabirds congregate near rocks (27). I made this drawing with pencil and did two studies of the birds I was going to have as my chief characters. I then built the main sketch up with pen and black ink, and finally used round watercolour brushes to apply the ink. In the final stage I did not concern myself with light and shade, because I wanted to

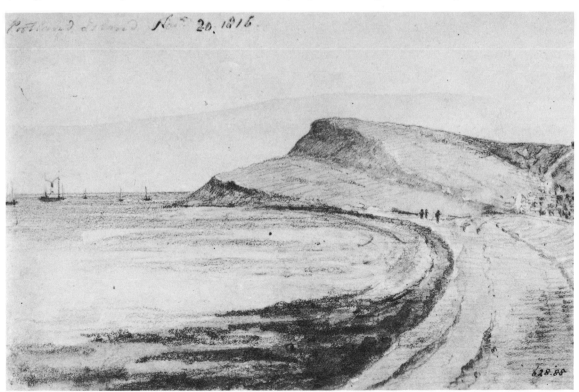

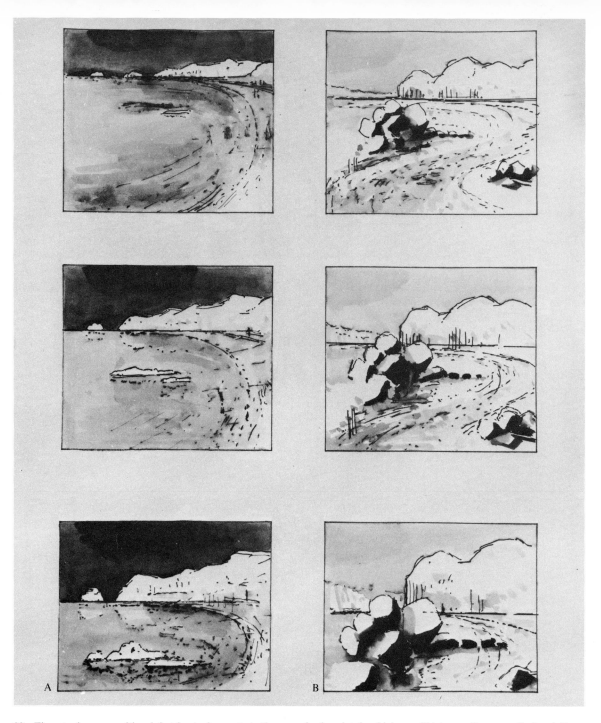

23 These twelve compositional sketches to demonstrate the variety of effects that can be obtained by shifting the horizon and water's edge lines into different positions on the paper. In each case a natural balance is achieved between the shapes above and below the horizon. The lower sketch in the composition of the bay and headland A is much like the Constable drawing of Portland Island. From the other two sketches of the same subject it can be seen what happens if the

horizon is taken higher and higher up the paper: the beach line becomes more dominant and the headland less of an important feature.

In the composition of the estuary and rocks B, as the horizon is lowered so the rocks in the foreground can be made into a more important feature: whereas with the horizon higher, the river estuary is more or equally important.

In the composition of the cliffs a low horizon C enhances the

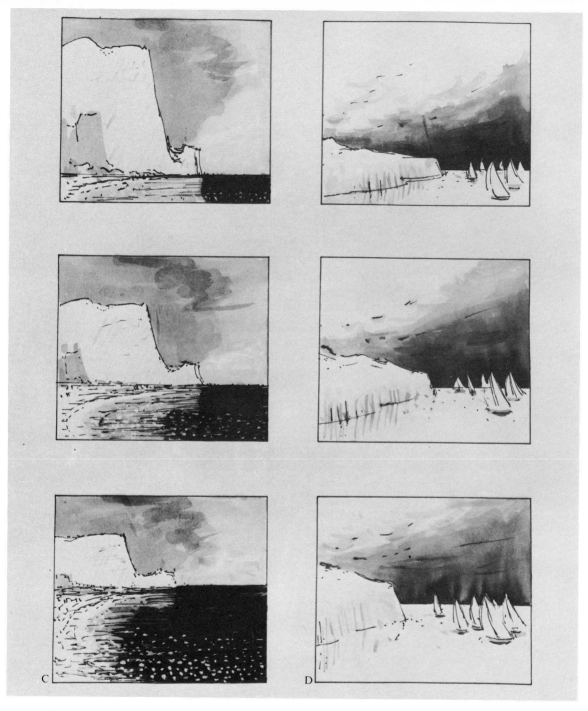

towering effect of the cliffs whereas with the high horizon the bay and beachline dominate.

In the last composition of headland and sail boats D the low horizon gives the sky a dominant role and a greater sense of space is achieved, the headland and boats appearing small by contrast. The higher horizon gives greater importance to the headland and the boats.

These compositional ideas are not offered to prove that some compositional effects are right and others wrong, but rather it is hoped they will show what a wide range of possibilities there is to hand. Also that they will aid recognition of the fact that composition is not something which is very special or difficult but part of the act of drawing and sketching. Any view that is taken will provide an interesting composition, and experience will show how effects can be manipulated and used.

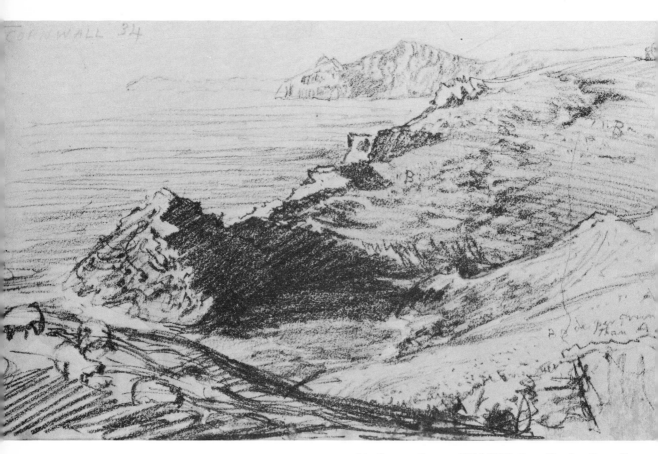

24 Samuel Palmer (1805–1881), *Coast Sketch at Cornwall*.
Charcoal. Sketch-book page (105 mm × 178 mm)
Victoria and Albert Museum, London

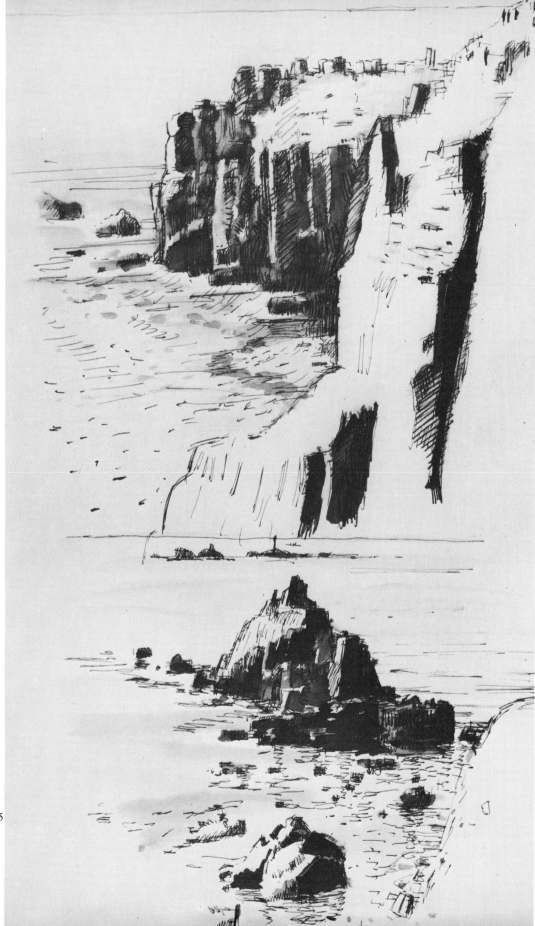

25

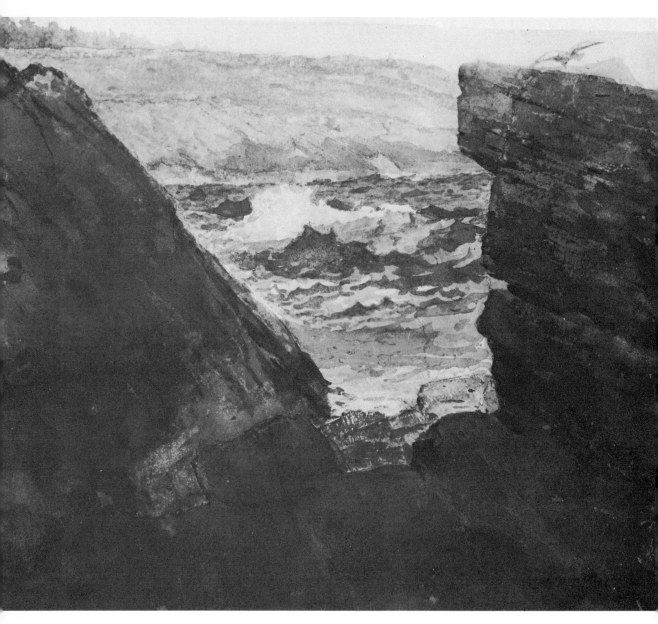

26 Winslow Homer (1836–1910), *Through the Rocks*, 1883.
Watercolour (289 mm × 356 mm)
The Brooklyn Museum, Bequest of Sindey B Curtis in memory
of S W Curtis

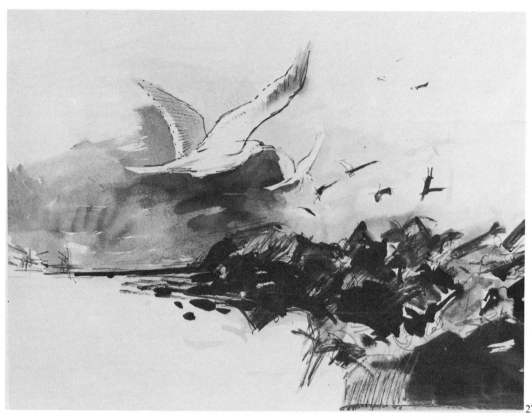

27a

27b

43

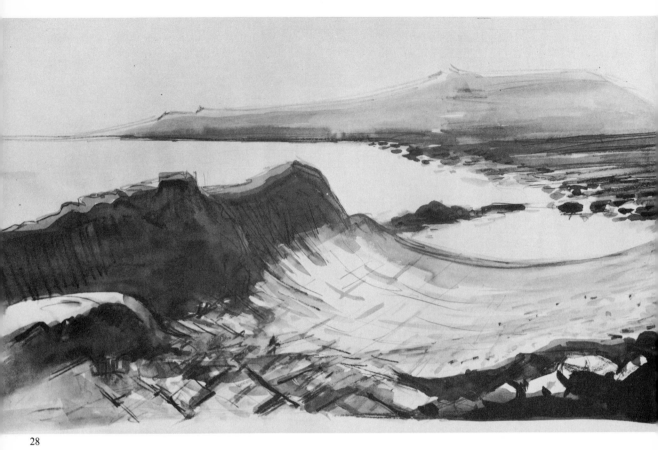

28

convey the wild movements of the birds buffetted by gusting winds. I made a jagged impression of the rocks so that the whole drawing should have a wild appearance.

Extensive views of bays and of distant headlands can create a different impression. In any weather they appear majestic, even awe-inspiring. I made a drawing of such a place with a *Black Prince* pencil at first, placing the horizon near the top of the paper so that I could show the sweep of the bay below and the upward surge of the sill of rock in the foreground. I then built the drawing up with watery washes and grey paint. I keep a collection of bottles of watered down black ink for this purpose. I aimed for an overall rather stark blue-grey effect (28).

Another variant on the coastal scene is to look straight out to sea, the coast at one's feet forming a frame round the lower part of the drawing. Cotman chose to do this for his very daring drawing of *Storm off Cromer* (29). I say daring because he chose to have the sea empty. The main features in this unusual drawing are the headland in the foreground

and the storm darkness of the sky diagonally opposite. I have studied this drawing with much pleasure many times in the British Museum. It is made with such simple means and yet conveys so much that I think I am always trying to probe its secrets. Notice the horizon position placed near the top of the paper so you get a good interesting division of the paper to start with. The sea is drawn with white chalk, incredibly subtle yet just right. There are a few birds, some people and one boat. The contrast between the sea and sky in white and black chalk, which also conveys the storm, is very clever. Cotman has been careful not to make the effect of distance in the sea and sky too great; he has used their textures for decorative effect rather than stressing their perspective. The format with rounded upper corners he used on a number of occasions, and no doubt was acceptable at the time.

In the beginning it is better to draw coastlines with headlands and bays from across a bay or estuary. From these positions it is easier to grasp the proportions and sculptural qualities of rock form-

44

ations. Stretches of coastline are probably best seen from the sea but this should be left for later.

My pen and black ink drawing (30) is of a typical bay facing to the north west. The time is late afternoon and the shadows are growing stronger in the east facing headlands. The water was very bright and the shadows were reflected in the water. I did not attempt to draw the sky but concentrated my efforts on establishing the rounded cliff tops. The light effect varied because of passing cloud, and in the end I had to complete the drawing from memory. Light effects at the coast are always changing, they are never twice the same for the same time of day, and so a study must not take too long. Two hours is a maximum and this would entail memory drawing towards the end. This drawing was made with a fountain pen with a medium nib. I smudged the free modelling of the cliff contours with water so that the shadow planes were unified.

This next drawing, by FREDERICK MULOCK, is again of the rounded promontory tops characteristic of the West Country but this time done in Devon (31). This is a small drawing carried out with crayon and charcoal which can give very broad lines. Here they have been used delicately, crayon first. All the shapes were first drawn in crayon, boats, houses, trees and hills and then were modelled with charcoal lines. Finally, watercolour wash was added to bring the near hill into a simple silhouette and darken the boats and bank at the water's edge. When the wash was run on, tiny slips of paper colour were left to bring forward the boats' masts, and other little bits of suggested detail of the bank top, to act as an added sparkle in the drawing. Of course the sparkle also clarifies the foreground of the picture and helps it stand out. Mulock's main theme was the shape of the hill and the boats, the composition has the effect of an unpretentious portait.

Some headlands are bare and stand out to sea on narrow promontories with a high cape like a castle. They are avoided by boats and ships which stand well out to sea, and on a quiet misty day they can appear ghostly. I drew such a one in pencil HB and B, and to catch the silent mood used pale blue grey washes (32). I did not feel that much modelling was appropriate and only used it on the castle-like head and a little on the ridge that ran out from the land towards it. I decided the sky should be in a half tone to bring the top of the drawing forward and be a contrast to the headland and the bright water beyond it.

29 JOHN SELL COTMAN (1782–1842), *Storm off Cromer*.
Black and white chalk on brown paper (276 mm × 547 mm)
Courtesy of the Trustees of the British Museum, London

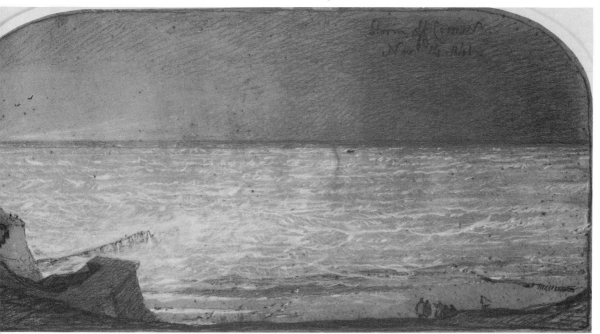

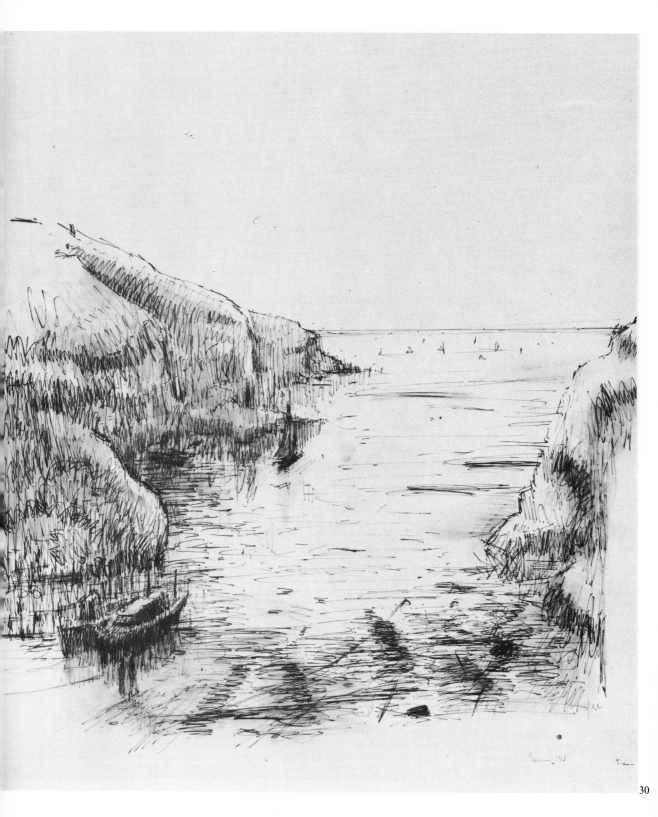

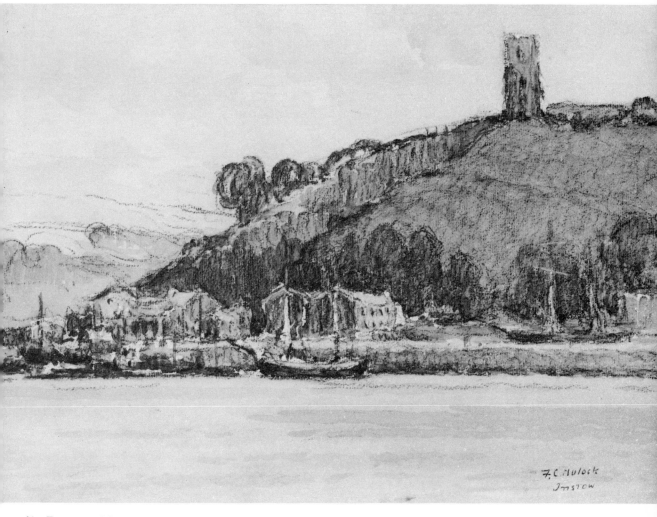

31 FREDERICK MULOCK (1866–1931), *Chanters Folly,
Appledore, Devon.* Crayon charcoal and watercolour
(267 mm × 381 mm)
Victoria and Albert Museum, London

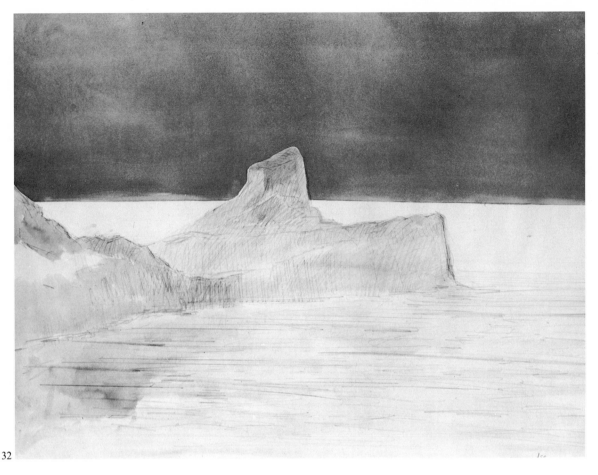

32

Coastal features

No coastal feature is more exciting than a castle, particularly this particular one which stands up from the shore (33). The walls of the castle rise from the rock face making an eye-catching monument. My drawing was started in pencil and then taken further with coloured crayons; this was in turn worked over with brown and black felt tipped pens. The sky, final modelling of the castle and water effects were in watercolour.

CONSTABLE was very fond of sketching by the sea when the opportunity presented itself. The view of *Folkestone* (34) drawn from a boat was made whilst he was on a visit to his children who were at school in the town; it is one of the very few pieces of work by the artist made from a vantage point at sea. How fresh and breezy this sketch is and it is completed with such a delightfully light touch. Notice particularly the slight undulating quality of the sea's surface caught by Constable's brush work, and also

the string of cumulus cloud above the land. Come back and look at this drawing when clouds and sky construction are considered in the following chapter.

One cannot go far along a coastline before discovering a beach. I have chosen two drawings of this subject which were executed in contrasting materials.

The first is a view along a beach set in a curving bay on a summer evening (35). The sweep of the bay and horizon were first drawn in pencil and then the drawing was built up in watercolour washes and gouache. Gouache was used for the sky and for the effect of the low hills and the buildings seen across the beach. The sun was setting and the final effect of hard shadow against the dying light was obtained with black *Conté* crayon.

The second is a view from the sea of a small seaside town (36). The beach was bathed in strong sunlight and was very crowded, the people moving

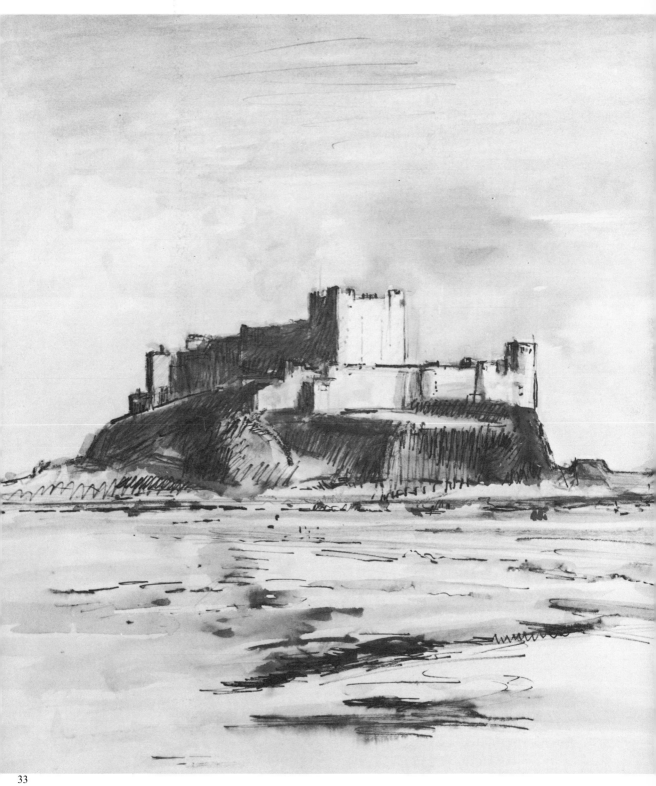

33

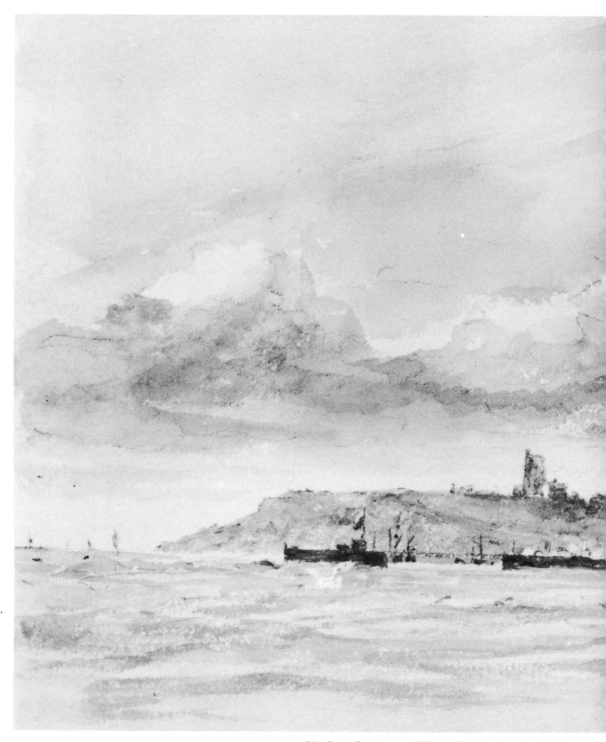

34 JOHN CONSTABLE (1776–1837), *Folkestone from the Sea.*
Watercolour (127 mm × 216 mm)
Courtesy of the Trustees of the British Museum, London

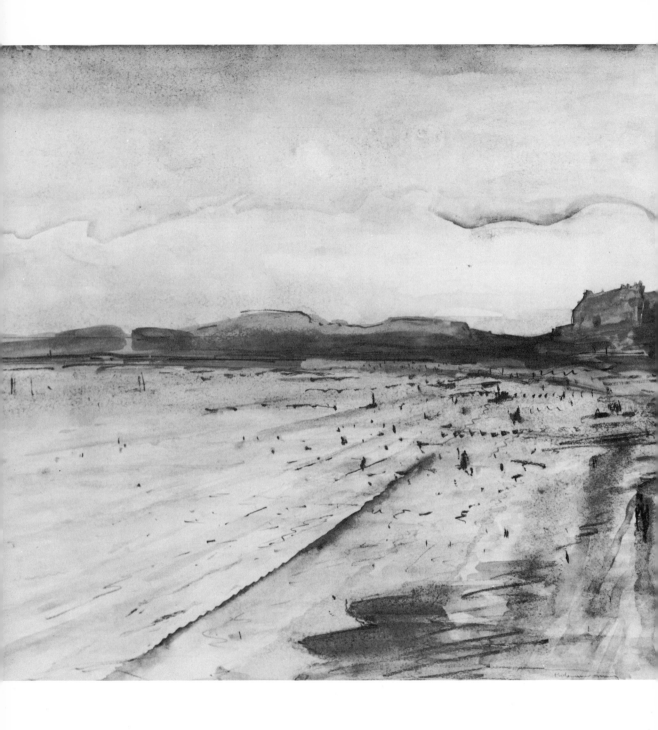

35 *Midsummer Evening. Conté* crayon, watercolour and
gouache (520 mm × 630 mm)

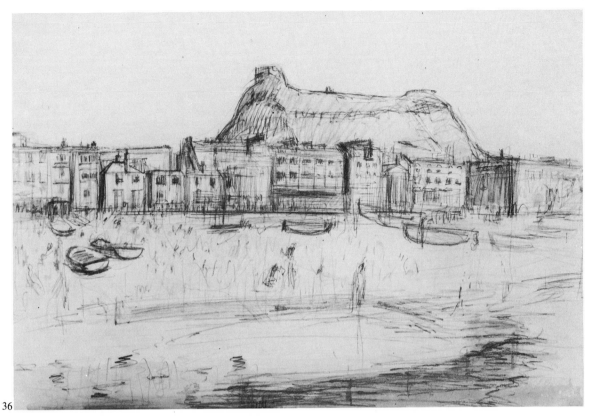

36

about continually. I used a *Black Prince* pencil at first and then went on to use a packet of coloured pencils. I mixed several colours to obtain darker tones to draw the shapes of the buildings and the hill beyond, as well as the boats on the beach. I contented myself with an impression of the people, leaving the paper fairly clear at the beach to catch the effect of the light. I deliberately allowed all the line markings to show because I wanted a linear effect to suggest sunlight, whereas in the previous drawing I wanted tonal areas for the suggestion of shadow.

Occasionally one may find trees growing near the beach. One may then see water framed by trees. The following drawings show the arrangement that might be anticipated. The first (37) is at the planning stage and the second (38) is complete. Both of these drawings are sketch-book studies. The first subject was selected from a number of views because the unequal massing of the trees each side of the water provided more interest. Equal balancing areas in a composition should be avoided if at all possible. I viewed the scene between the trees and then indicated the shadows with light grey tones. So I started

this sketch with a brush and wash. Don't be too anxious about trying this form of start, but when you do, make sure that you use a very pale tone at first: one that can hardly be seen when it dries. You can always add another one over it later. With this drawing I then used my fountain pen to add the contours to the masses of foliage on the trees, the hills and the winding river shapes. Finally I tried some heavier tone for the water in the foreground. Building up with washes of pale tones and then using a pen line is a most agreeable technique for composition planning or rehearsal.

The second, but completed view through trees, was drawn with 2B, 4B and 6B *Conté* crayon (38). The main shapes were drawn with 2B crayon. I deliberately included more of the tree on the right hand side than on the left so that I could gain in visual interest. I could have had equal amounts of tree each side but the result might have been very ordinary and boring. A good amount of time was spent in establishing the correct proportions for the tree and where the dark portions of the banks would be in the foreground, as well as the shape of the tree foliage coming in from the top left hand corner.

53

37 *Reflections*. Pencil (490 mm × 620 mm)

Once this was done the drawing was steadily built up with the heavier crayons, and the anchored boats given extra touches. The position and scale of the boats was indicated from the very beginning of the sketch and were kept in mind throughout as the main subject of the drawing and focal point of the composition.

Rivers and inland water

Rivers extend the world of water inland from the sea; some are large enough for the commercial passage of ships and all sooner or later wind through the countryside and are famous for their individual beauty spots. A river's mooring places, quiet corners, villages and bridges provide an endless variety of subjects for the artist who likes to be near water. Some rivers have rocky stretches and fast flowing currents; there may be waterfalls deep

inland, or still reaches where on a sunny day there are bright reflections. All these things have pictorial value.

The majesty of a river can sometimes be felt from a view of its lower part where it meets the sea. Here it will be tidal and have shoals and banks. It is always a visually exciting location in any weather and very moving to look across the wide water reaching out to the sea at the distant horizon.

My drawing of an estuary (39) was scrubbed onto the paper quite heavily and unrelentingly until it

was finished. Immediately I saw the sweeping bend of the river bank etched against bright water I wanted to convey the shape on paper. I used three or four ready sharpened *Black Prince* pencils to get the shape of the banks in the river and the land shapes on the horizon. I ignored all the detail in the foreground for my subject was the visual surprise of the river shape and the bright water joining the sea. As the pencil work progressed I indicated clouds with watered-down black ink. I felt that this was an appropriate change of material, its softness enhanc-

39

ing the sharpness of the pencil work below.

Colour plate 2 shows a watercolour drawing of the inland water or lagoon at Venice in 1819, made by TURNER when on his first Italian tour. It is remarkable both for its rendering of light and the lucidity and certainty of its drawing. It is one of four watercolours of Venice in his Como and Venice sketch book.

Turner drew incessantly and filled a great number of sketch books during his life time. In 1819 he filled nearly a score of small ones with pencil drawings; as well as a number of longer books of which the Como and Venice is one. Much of his painting was done in the studio with the aid of the sketch book material.

What he searched for in his small drawings was a particular balance, or order of marks, by which he could begin to give some substance to a subject on paper, and it is known that he liked doing many of these small sketches for every larger watercolour completed. Colour was still recognised, however, in the smallest sketches by means of written notes giving descriptions of colours, their textures and tone values.

It is apparent from this, and other studies, made in 1819 that Turner was not only discovering new means of recording his sensations of light and colour effects, but was also exploring the use of a more wide angle view.

The foreground stretch of water is broad and extensive and yet filled with suggestions of reflected sunlight, reflections and the languid movements of the water surface. The horizon is positioned so that the sky forms the largest area of the picture and provides space to display the growing effect of the sunrise. It occupies about two thirds of the total picture and provides the necessary repose which balances the usual activity of the boats, ships, building forms and lagoon water.

Scanning from left to right across the horizon, and middle distance, the drawing is full of interest. A distant strip of land marks the edge of the channel that passes San Giorgio to the north; dotted over its length silhouetted against the sunrise are many ships and boats. Nearer ships and boats are moored by San Giorgio island. To the right, more in the foreground, clusters of other boats and ships stand forward marked in darker tones which forces the eye to travel back through the square perspective of the church and on into the sunrise. Everywhere

Turner contrasts and lightens tones so that the spectators eye is always moved into the drawing, from foreground to distance, over the lagoon. With the addition of colour the effect is magical and displays Turner's talent for depicting atmosphere over the water.

In the drawing he has also ensured that the maximum of artistic effect can be gained from the masts of the shipping and the perpendiculars of San Giorgio architecture and the other buildings. Scattered across the horizon these uprights create a varying internal that is a delightful foil to the joining of the sky and water.

Although I have been discussing details it will be recognised that there is an overall breadth of treatment in the drawing which transcends all its

parts; in front of the drawing, first and last, we are moved by its totality, Turner's skill is unrestricted by any part of the scene and it is his total vision that we see.

In flat lands one can see across extensive water or low lying ground to the sea; from under a wide sweep of sky stretching down to the horizon this can be very moving.

For the *Fenland* drawing (40) I again used watered-down black ink in washes, but I drew with a 4B *Conté* crayon. In the first stage I sketched the perspective lines of the waterway, the lines for the

40 *Fenland*. Ink and *Conté* crayon (475 mm × 650 mm)

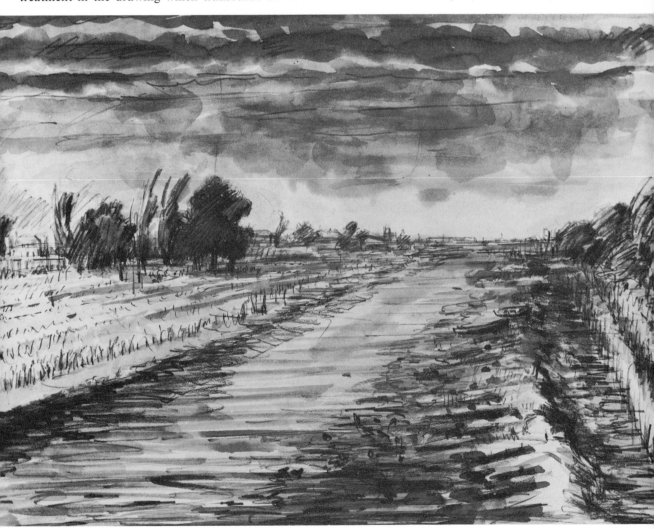

57

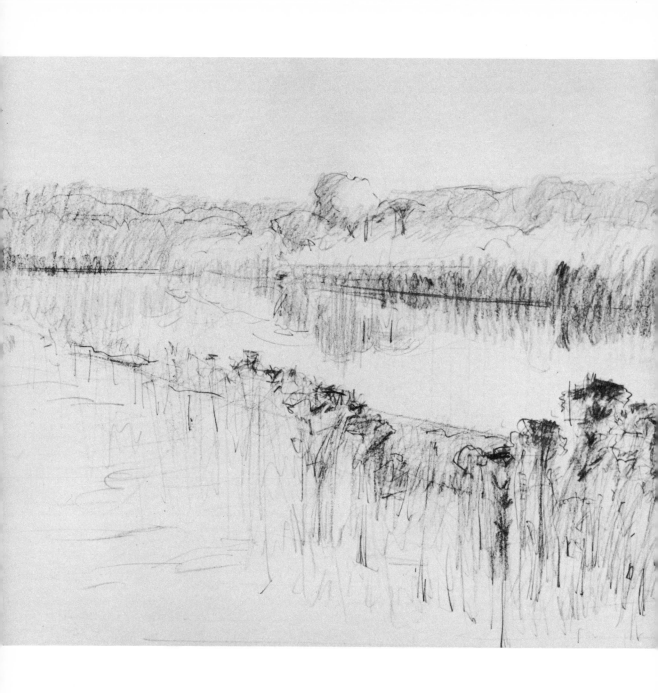

growing crops and the ditch on the right hand side of the drawing. These guidelines all met up at the horizon. The sky was then put in with a watercolour brush which I drew across the paper in horizontal lines. Darker at the top of the paper and lighter towards the horizon. I then started to draw the trees, farmhouses in the distance, and the varying textures for the water, banks and crops. I did this in two separate stages or layers. Between I used inky washes throughout, and finally completed the drawing with the inky wash technique. This made sure the whole drawing held together and that also I could get the effect of pale sunlight coming from the left by toning down any areas that still needed this treatment. All this was done with my eyes half closed, the only method for the achievement of a unified effect.

Quiet rivers or peaceful stretches of water are one of my special delights. There is no feeling of rush or tension in landscapes through which they move. The water may be under great pressure from hidden sources and have great power but outwardly all is calm. It is as if nature has achieved a precise and happy equilibrium. I made a study of a long straight stretch of such water (41). It was early morning in late summer, with a clear sky and the sun already risen. I used an HB and a B pencil and a mixed box of coloured pencils. As in the previous drawing I established the main perspective lines first. I then indicated the proportions of the weeds on the nearest bank and the clumps of trees and their reflections in the river on the far bank. The edge of the far bank was thickly overgrown, only the tops of all the foliage catching the sunlight. I carefully modelled all this, checking the proportions of the reflected image at the same time. I then overworked all the previous drawing with green and blue coloured pencils. Being early morning there was nothing in the scene that was strongly or warmly coloured. The drawing was then completed with touches of yellow pencil throughout, with oranges, reds and stronger blues in the foreground. I felt that the most important features of this drawing were the weeds and the reflections, and that the overall effect had to be kept light and airy.

41

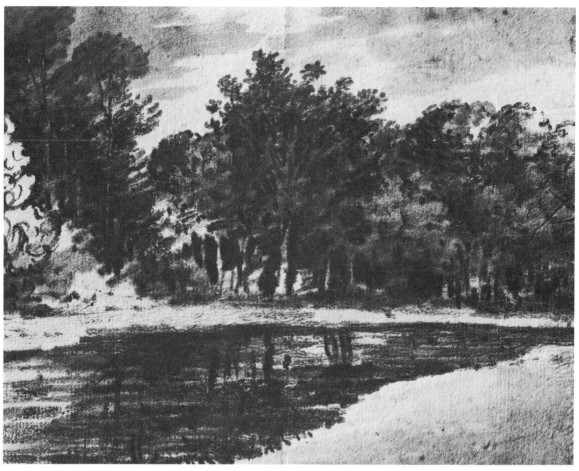

42 THOMAS MONRO (1759–1833), *Landscape: A Pool in the Foreground and Trees Beyond.* Indian ink (162 mm × 203 mm) Victoria and Albert Museum, London

I admire the study of trees by a river by THOMAS MONRO (42). Very straightforward in its approach there is nothing fussy about the composition and the drawing has been taken far enough to be thoroughly convincing. Things to note about the technique used are the unified oblique crayon treatment to complete the foliage of the trees; the horizontal crayon movements to draw the mirror-like surface of the river water; and the brief directness of the supporting watercolour wash. The reflection of the trees in the water is well suggested, correctly the reflection is not over sharp because the trees are in shade and therefore not very bright.

For the bend in the river (43) I used a very mixed technique. I planned the layout of the scene with an HB pencil and then used a mixture of 2B *Conté* pencil and charcoal pencil. Again I smudged to unify, and the drawing became quite black. I then decided to complete it by using black and white ink with a small watercolour brush. The ink was used mostly on the plants in the foreground and the bright water. If this drawing demonstrates anything it is that however messy a drawing might become it is never entirely lost and should not be abandoned too quickly. This drawing was a hard struggle and at one stage I nearly despaired of it working.

I choose this less well-known and rather unusual drawing of a river scene by TURNER because I think it shows how satisfying the simplest view of nature can be for an artist (44). There were no obvious grandiose features in this view and yet enough has been found to make a drawing with plenty of visual interest. In the foreground the broken water of the stream swirling under the wooden footbridge is framed by the darker tones of the river bank and the

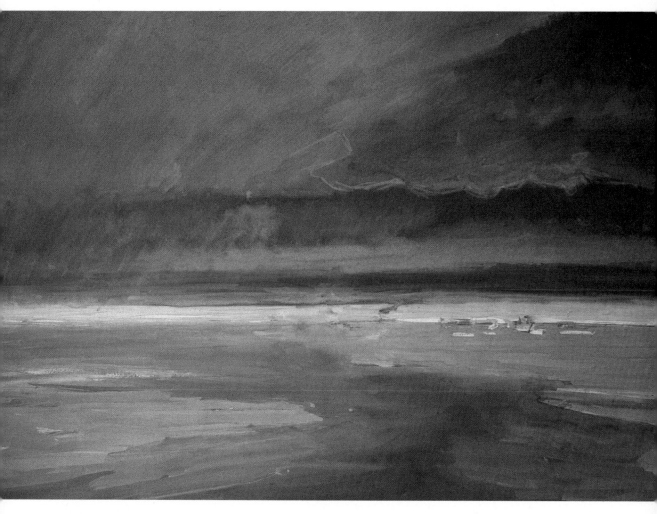

Plate 1

JOHN CRONEY, *Distant Boats on the Estuary.*
Pencil, watercolour and gouache, 762mm x 559mm

I deliberately chose a wide-angled view for this scene
so that I could create an effect of space and the
atmosphere of the place which I felt so strongly.
The sky seemed vast across the flat land and appeared
to merge with the water of the river mouth and the
sea beyond.

The first mark I made was the horizon line, followed
by marks in the sky for clouds, and then I used lines
to place the edge of the river and the boats. Using
watercolour, followed by gouache, in a series of
closely related tones, the colours of which were
sombre, yet rich, I built up the sky and land. For the
distant boats I used light colours, for although at a
distance they appeared formless, they were the only
bright objects to be seen

Plate 2
J M W TURNER (1775–1851). *Venice, San Giorgio from the Dogana: Sunrise.* Watercolour (224mm x 287mm) from Como and Venice sketchbook 1819 *Courtesy of the Trustees of the British Museum, London*

Plate 3 *(Opposite)*
ANGELOS GIALLINA (active 1850-1895), *A Boat with Three Fishermen.* Watercolour drawing (590mm x 350mm) *Private Collection*

Plate 4
WINSLOW HOMER (1836-1910), *Sloop, Bermuda,* 1899.
Watercolour (381mm x 546mm). Copyright 1982
*The Metropolitan Museum of Art, New York,
Amelia B Lazarus fund, 1910*

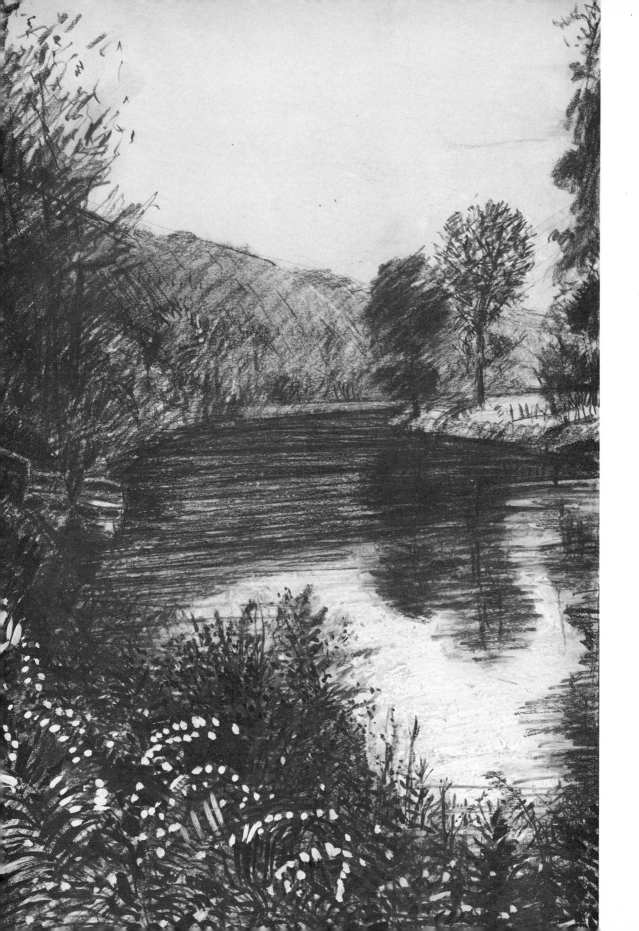

bridge itself. Pen drawing and watercolour wash pick out the trees beyond, and then further back still a long line of trees, nearly at the horizon, crosses the drawing. Remarkably all this is on quite a small sheet of paper. The sketch may seem unremarkable as a Turner, but I think it is inspiring to see for it shows what can be done when away from a more obvious dramatic composition, and the happiness and contentment that can be found from working in a quiet corner.

The watercolour drawing by JAMES FLETCHER WATSON shows another approach (45). Here the trees are stated simply and directly, their foliage is light and springlike. Much winter water remains and the artist has skilfully suggested it by an

effective statement of the reflection of the trees and fence posts. The spreading flood water is crisply drawn with dark accents round the edges which portray its flat mirror-like quality.

The simple mirror-like quality of calm water is well depicted in HENRY BRIGHT's study of a river and bridge (46). This drawing was executed in monochrome and white crayons. The drawing has at least two outstanding features which are worthy of study. The first is the suggestion of the river, and it is a suggestion rather than elaboration. There are a few horizontal marks used to show the water's flat surface, and then there is a suggestion of the reflection of the white bridge and house end, finally in the foreground we have the bird skimming the water surface, its position pinpointed by its reflection. Rightly, Bright has kept the drawing of the river simple because he did not want to detract from the drama of the storm cloud above the bridge. The storm cloud is the second feature I would draw

44 J M W TURNER (1775–1861), *River Scene, Post on Bank*. Watercolour, pen and ink (231 mm × 295 mm) Courtesy of the Trustees of the British Museum, London

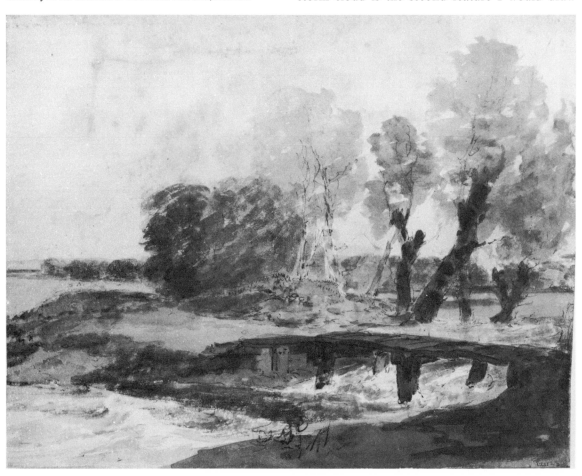

attention to. The tonal contrast between the black storm cloud and the white bridge is extremely exciting; it makes a visual shock. Although this kind of effect cannot always be obtained, nor would we wish it to be, it is nevertheless valuable to have a record of it. It is a fine example of the effective use of black and white. Notice how the storm cloud and bridge are kept off centre, and simple in execution, yet balance with the textured drawing of the plants on the river bank to the left.

Drawing 47 shows a river surface drawn in misty conditions. The far bank the Abbey remains and other details are not clearly visible, although shafts of light break through the mist. The shine off the river surface in the foreground was quite strong and

showed the direction in which the water was moving. A wide range of pencils was used from HB to *Black Prince*, the final marks however were white ones made with an eraser for the light and the reflection.

Another drawing of a reflection was made from a much wider river (48). In this situation the reflected trees were more sombre because the general light was less brilliant. It took a long time to prepare the drawing. The proportions of the shapes of the bank on the right side, and the tree masses above them had to be carefully calculated so that the correct perspective was obtained. This took nearly an hour to resolve. I started the drawing with a 2B pencil and completed it with 4 and 6Bs. I used a pencil eraser to clear out some of the light planes of the tree foliage and to make the sinuous curved shape for the edge of the reflection.

It was a special delight of Cotman's to sit and draw by water, and I have selected what I consider

45 JAMES FLETCHER WATSON, *Flood Water at Windrush 1979*. Watercolour (210 mm × 311 mm)

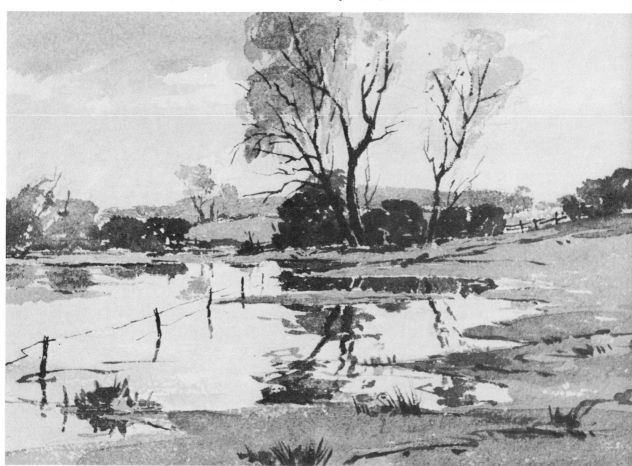

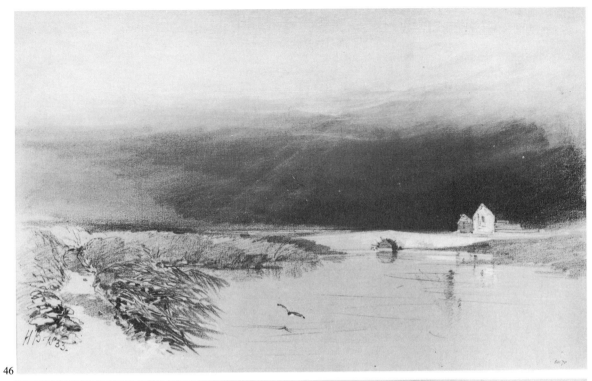

46

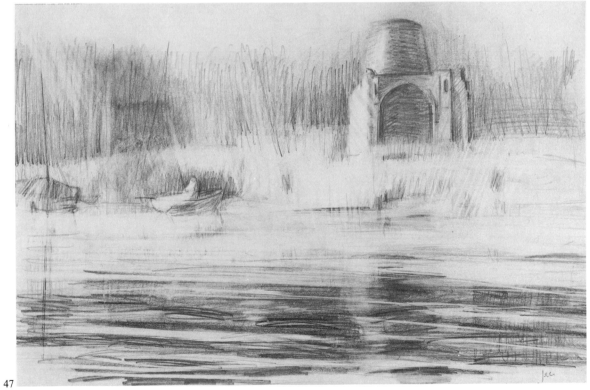

47

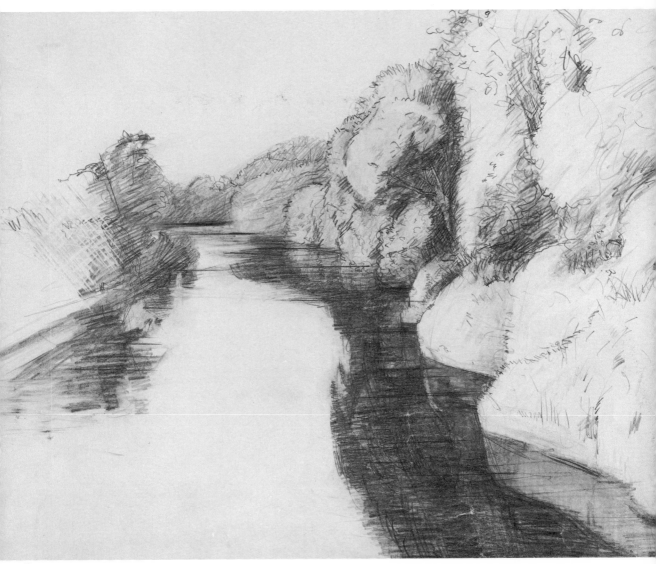

48

to be two outstanding examples of his work done on these occasions.

The drawing of cattle grazing beside a lake is also carried out entirely in pencil (49). COTMAN may have commenced with a harder lead but from the pencil marks that can now be seen it appears that he completed the drawing with soft leads. The tree trunks and the house and wall by the lake are bright

46 HENRY BRIGHT (1910–1873), *Landscape With River and Bridge: Rain Coming On.* Crayon (282 mm × 450 mm) Victoria and Albert Museum, London

so that their reflection in the water is quite clear. The drawing shows a high standard of pencil technique, and is an excellent example of the range of tone that can be achieved with pencil alone. It is interesting as well to see the great care that has gone into the execution of the composition. Each shape has been carefully drawn against the shape behind, and there is a continuous counterpoint effect gained by making every tone contrast with the one next to it. Some may feel it is too controlled; but for what it demonstrates about pencil technique, look at the reflection as a passage on its own; it has great value.

Barton from Irstead Broad is freer and again

49

50 Barton from Irstead Broad

66

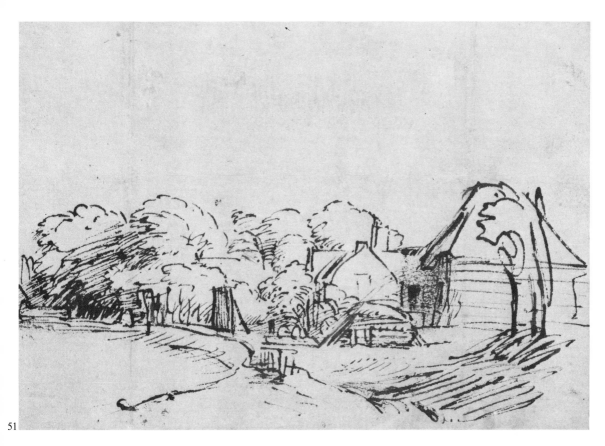

51

49 JOHN SELL COTMAN (1782–1842), *Cattle Grazing Beside a Lake With Trees and Cottage on Right*. Pencil
(197 mm × 263 mm)
Victoria and Albert Museum, London

50 JOHN SELL COTMAN (1782–1842), *Bartom From Irstead Broad*. Pencil and white chalk on light grey paper
(205 mm × 349 mm)
Courtesy of the Trustees of the British Museum, London

51 REMBRANDT VAN RIJN (1606–1669), *The Amstel River*.
Reed pen and brown ink (126 mm × 197 mm)
Courtesy of the Trustees of the British Museum, London

shows how Cotman was able to use his wonderful talent for reducing the variety of natural forms in a view to an orderly sequence or pattern (50). Similarly each shape has been carefully drawn and given a tone in relation to the shapes next to it. The construction of tonal contrasts has been helped by the use of white chalk for highlights on a light grey paper drawing base. This is an altogether delightful, as well as a powerful, drawing of water. I like it none the less because it is a working drawing with a list of

instructions for himself written on the top right of the paper. 'Boathouse – cold grey; 5 rich brown *wood*; 3 golden yellow – reed beds'. These cryptic notes are in fact mouth watering descriptions of parts of his subject; they illuminate the contents of the scene for us, just as they would have done for him when he returned to look at the drawing sometime after it had been completed. In this drawing the representation of still water is outstanding, all the reflections are so keenly wrought that the water of the broad appears to be like a mirror.

With REMBRANDT'S *Amstel River* we leave pencil technique and can consider what can be done with the pen (51). Rembrandt made hardly any landscape paintings, although he left us a wonderful series of portraits. However, he did make a large number of landscape drawings, and quite a few of these were made in pen and ink near or beside the Amstel river.

His drawings to this day remain unconventional. Perhaps this is in part due to the fact that he nearly always drew with a broad tip; either a stub of chalk

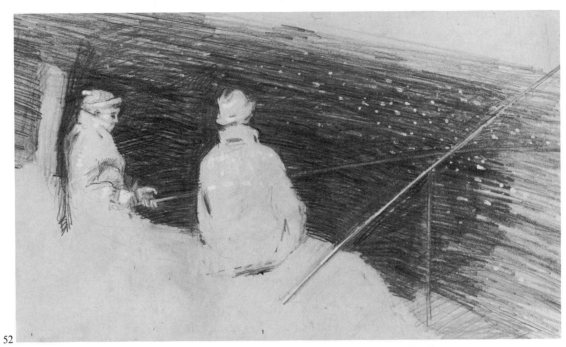

52

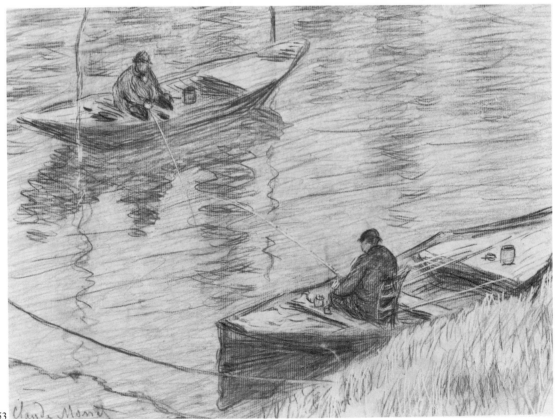

53 *Claude Monet*

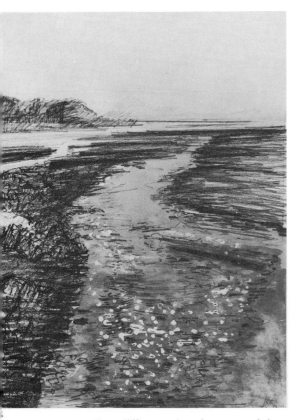

or a pen. For different drawing materials each produce their own type of mark or line, and so each artist will choose materials that suits his expressive ideas the best. With a reed pen, or a quill pen, two of Rembrandt's favourite methods, there is no turning back once a line has been started; if you do turn back the pen digs into the paper and splutters. The method requires the lines to be formed as in writing. The lines can of course be made thicker or thinner with pressure and they can also be used to make telling rhythms. Look at the small clump of trees in the far right foreground of Rembrandt's drawing; you can see that in this last effect he was its master, and it is his inspired use of the pen line that compels attention, the subject being a pretext for this method of expression. No one in his superior at exploiting the pen's possibilities for drawing. With it he entices us to use our imaginations and enter

into the spirit of what he has created. He was by nature reticent and not given to using effects of light and shade bombastically, so although he uses powerful marks his drawings have an intimate quality. They pull you in rather than rush out to meet you. They do not obviously charm but seem to breathe an eternal mystery that not only lies in the subject but beyond it.

Where there is a river, sooner or later there will be fishermen. This drawing of two fishermen was made in the winter (52). I started the drawing with blue, green and yellow pencils which helped me to catch the atmosphere. However, I rapidly went on to use a 2B pencil. In the final stages I used white ink with a brush to pick out the fishing rods against the water, and to suggest the sparkle of light from the ripple of the water surface. When a water surface is animated or troubled it is broken up into thousands of small tilted surfaces each one of which can act like a mirror if it is facing the light. I made the water surface round the men very dark so they could be seen as light silhouettes against it. I felt that they should be left without much drawing detail on them.

My favourite drawing of men fishing is this one

53 CLAUDE MONET (1840–1926), *Two Men Fishing*, 1882.
Black crayon on textured paper (256 mm × 345 mm)
By Courtesy of the Fogg Art Museum, Harvard University
Bequest – Meta and Paul J Sachs

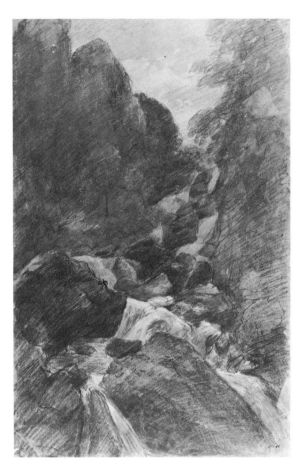

56 JOHN CONSTABLE (1776–1837), *A Waterfall in the Lake District*. Pencil grey and pinkish wash (386 mm × 245 mm) Victoria and Albert Museum, London

reflections. It is all so fresh and exciting and yet the scene itself is quiet and unexceptional. Monet's passion was for depicting light and movement, and he still manages to convey them even from this seemingly unprepossessing view down onto a piece of water. I think perhaps the water is the subject rather than the fisherman.

Stones, rocks and water are often found together. In wild and barren places river water can run out to the sea through rocks (54). I made this study in black and brown crayons and used blue washes. The subject was water running out to sea round stones and rocks. The effect of glinting reflected light from the rippling water was obtained by dotting the paper with candle wax points after planning the composition with light crayon lines. The coloured wash over left the paper white where it was covered with grease, as I have explained previously. I decided the horizon should be high so that I could have as much space for my water subject as possible. The rest of the composition built itself up because all the rocky land shapes were so interesting in themselves.

This is another view of rock and water. This time the rock is wedged together as trimmed stone to form a bridge. This drawing is in *Conté* pencil. Bridges are excellent subjects, making compositions in themselves. This was a sketck-book study although I worked on it for nearly two hours. The stones of the bridge were kept light against all the foliage beyond. Both this foliage and the bridge reflection gave plenty of scope for free pencil work (55).

The final illustration for the drawing of water is a study of a waterfall by CONSTABLE (56), probably made during his tour of the Lakes in 1806. It may appear unusual for Constable because of its sculptural qualities. But, as we have already seen, the wonderful thing about rocks and boulders is that they encourage a search for form and solidity. This study is in pencil but a watercolour wash has been used as well. The main point of interest has been kept low in the drawing; it is where light reflects from cascading water. All the rest of the drawing has been toned down so that this portion should stand out and catch the eye. This toning provides a unity of effect which Constable had already achieved by free diagonal pencil work, but of course the pencil work gives the drawing life and animation.

by CLAUDE MONET (53). It is drawn with a black crayon on paper painted with gesso. Gesso is a thin form of plaster coating which gives a soft white surface. The thin plaster coating allows for scratching out of, or through, the pencil work. You can seen an example in the foreground where Monet has scratched out in white lines to represent the grass blades. He has then drawn more on top with pencil. This is pencil work that I admire; it is both free and yet certain. Look at the drawing of the water surface. Think of the application of the countless pencil strokes that make up this drawing. What a worker and what fun he had working! Notice the life there is in the squiggles that represent the

The Sky and Clouds

In a seascape the sky will sometimes be a more prominent part of the scene, particularly where it heightens the dramatic effect; and there will be moments when we are more in love with the sky than the rest of our subject.

What makes skies so absorbing are the varying forms of cloud which pass across them and the variety of lights in which they can be seen. Cloud may be heaped up in huge masses and appear heavy and threatening, and yet the same formation lit by strong sunlight could seem light and radiant. Other cloud can be in the form of fine curled filaments or be threadlike, or in white flakes or sheets. The variety of the effects of light from the sun is endless. I have never seen the same effect twice. It may be completely clear of cloud or completely veiled, with infinite permutations of being more or less obscured in between.

The watercolour drawing by DAVID COX of *Rhyl Sands* is a wonderful example of the use of sky and cloud for dramatic effect (57). The rendering of the storm clouds, the rain in the distance, the passage of broken light, and the wind blown people on the the beach, are very fine and make it an outstanding work. Although it is so free and animated in execution and appearance, and so full of the artist's feelings, its final success was dependent on the firm adherence of the artist to some basic drawing notions. I chose this work as the opener on the subject of skies because it is such a good demonstration of what has to be done to make a sky in a drawing acceptable, or 'work'.

One notion we have to keep in mind when drawing skies is that planes which are parallel to one another appear to vanish to the same horizon line. Cox keeps the plane of the underneath surfaces of the cloud formation parallel to the plane of the sea and land, and both are executed in a perspective that suggests they meet at the horizon. The sky 'works' because the cloud base has been conceived as canopy parallel to the earth's surface.

Another important notion is that the darkest darks and the lightest lights in a drawing must be kept in the foreground. The contrast between light and dark makes the tones stand forward. Less dark darks and less light lights, placed together, give an effect of recession or depth, the more muted the light and the greyer the dark, the greater the depth obtained. This notion comes from the fact that if we look at any scene we shall see the strongest darks and lights in the foreground, whereas in the distance or far distance, it is extremely difficult to determine any tonal differences. Even on a clear day we see less clearly the further we look because of the density of the atmosphere. An artist calls this effect atmospheric perspective, and tries to interpret it in order to render a suggestion of depth.

Cox does just this when drawing his sky. In the top left he leaves some areas of white paper to contrast with the dark cloud, and above the horizon the sky is almost an equal tone to the distant sea all the way across the picture. The darkest areas on the cloud base are kept in the foreground.

The atmospheric perspective of the beach and sea is established by the same means. On the beach, dark and light contrasting texture is kept to the foreground. On the sea, the lightest wave tops are kept near the beach, and the sea is toned down as it nears the horizon.

I recommend this drawing for continuous study for it has so much to show both in technique and artistry.

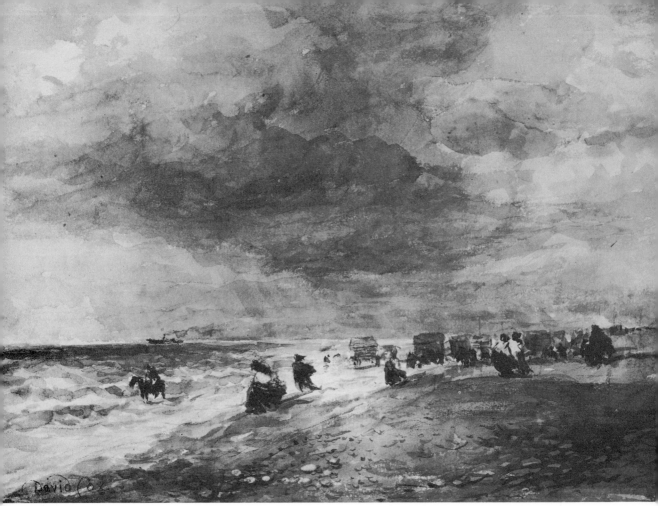

57 DAVID COX (1783–1859),
Rhyl Sands. Watercolour
drawing (261 mm × 362 mm)
Victoria and Albert Museum,
London

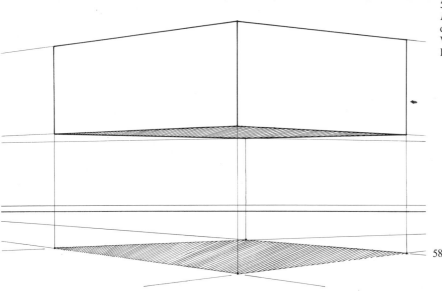

58

72

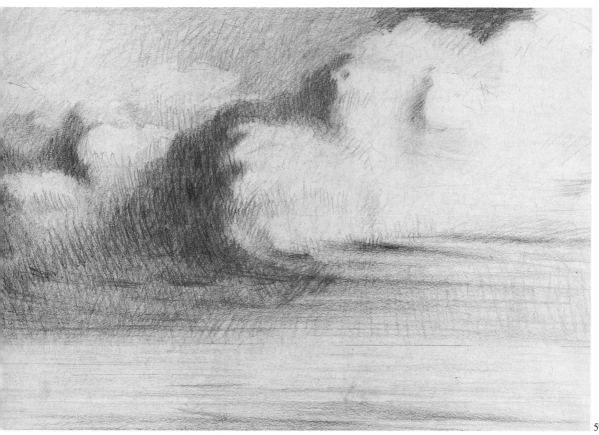

Although clouds may not appear to be like simple solids at first glance, it is nevertheless useful to consider them in this way for this conception will help when trying to fit them into the sky and give them depth. I have drawn a simple, if somewhat exaggerated and mechanical, diagram of how it might be best to start thinking about them (58). They *do* have depth, width and height, and they *do* float above the earth's surface, and so if lines were produced down from some aspect of them they would have a specific relationship to the surface immediately beneath. This is an extremely important initial concept to hold, and will help to avoid many unhappy hours struggling with formless skies. So often the best friend of an artist trying to obtain substance and depth is the simple box-like form.

I have made a study of cumulus cloud in 3B pencil so that it may be apparent where the idea of the box may lead (59). The sunlight was shining from the right, the planes of the cloud in shadow going away to the left. The greatest contrast between light and dark planes on the cloud being found in the foreground.

The next diagram is also exaggerated but I hope it gives a more general sense of the construction of a sky that contains several clouds (60). I have used a series of small cumulus clouds to show how they might appear one behind the other, going back in perspective towards the horizon. I have kept them separate so it can be seen how they appear smaller the further they are away. I have indicated the underneath surface of each one so that the cloud base could be realised and understood. I have also made a stressed marking with a heavier wash and accent on one near corner of each cloud so that the trick can be learnt of bringing a near corner of a cloud forward. Look and see how Cox does this (57). If you can imagine all the underneath surfaces of the cloud joined together, then you have the concept of the cloud base as a canopy. Although the diagram is artificial in its regularity, it nevertheless conveys the sense of cloud floating in layers above the earth's surface.

By the use of another diagram (61) I have tried to convey a further aspect of cloud depiction that we

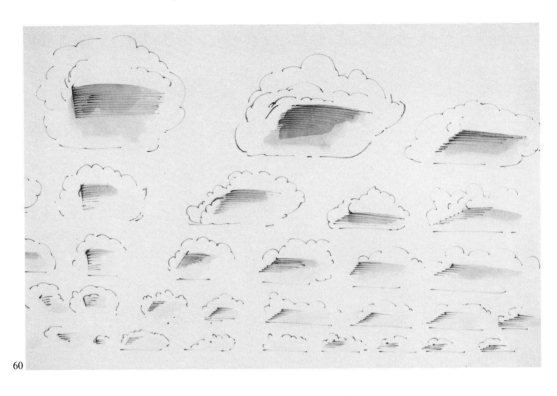

60

61

74

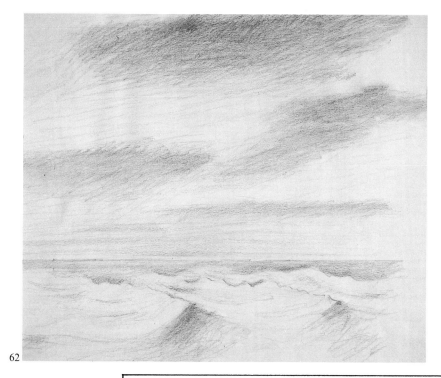

62

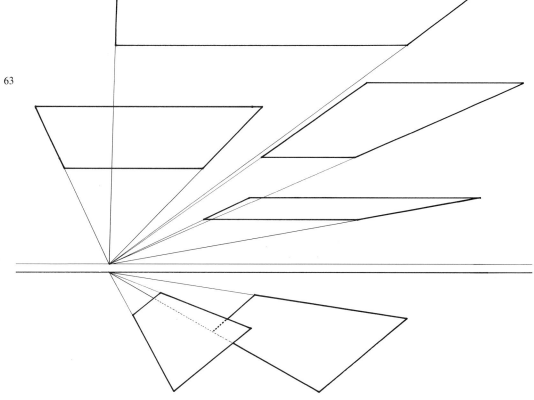

63

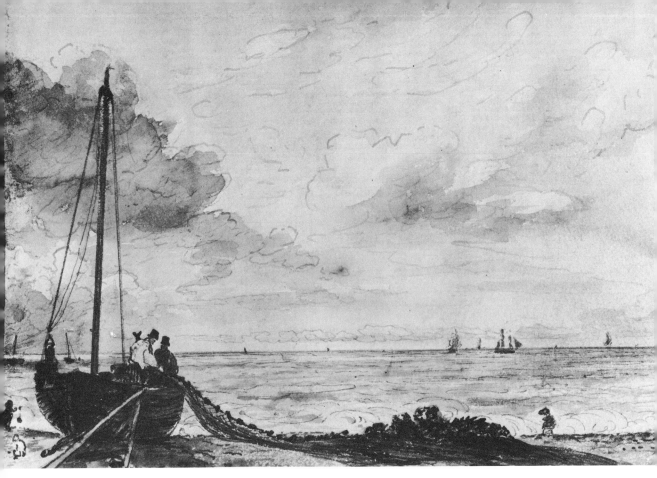

must use. Although clouds appear to vanish to-wards the horizon, just as the sea and the land does, from the lowland point of view, the two will never touch. If we travel across water or flat land to an horizon point, the clouds will still be above us. For this reason, when drawing the clouds and the sky they must always be shown to *lift* above the horizon. In the diagram I have attempted to convey that a cloud base is in reality curved, and follows the curvature of the earth's surface. This concept will give us the sense of clouds coming *up over* the horizon and rearing above us. Cox has left a light passage all the way along and above his horizon line so that he could convey his feeling that the clouds and the sea do not touch. The light passage *lifts* the sky above the sea. If colour is being used, it is helpful to make the sky just above the sea slightly warmer than the rest of the sky or sea colour.

In the diagram (58) I have shown how clouds should be considered as volumes which have a specific relationship to what is below them. I would like to pursue this idea a little more and explore a more natural usage of the concept. I have made a pencil study of sheets of dark cloud moving above

64 JOHN CONSTABLE (1776–1837), *Brighton Beach with Fishing Smack*. Watercolour drawing (185 mm × 260 mm) Victoria and Albert Museum, London

the waves of the sea (62), and, in the accompanying diagram (63), I have made a formal analysis of the construction lines that I used. I conceived both the clouds and the wave formation to be vanishing to the same point at the horizon. I have kept the two vanishing points separate, one above the other, because I do not want the idea of the clouds not touching the sea at the horizon to be forgotten. From the vanishing lines of the cloud edges it can be seen how I felt some clouds to be nearer me and directly above the near wave peaks, other clouds further back in the sky and one even further back above the more distant wave peaks.

I have chosen one of CONSTABLE's studies of the beach at Brighton (64) as an example of what can be achieved by slight means when sketching skies, if a feeling for the space between the cloud base and the sea surface is maintained. Notice first how Constable has lifted the sky above the sea at the horizon.

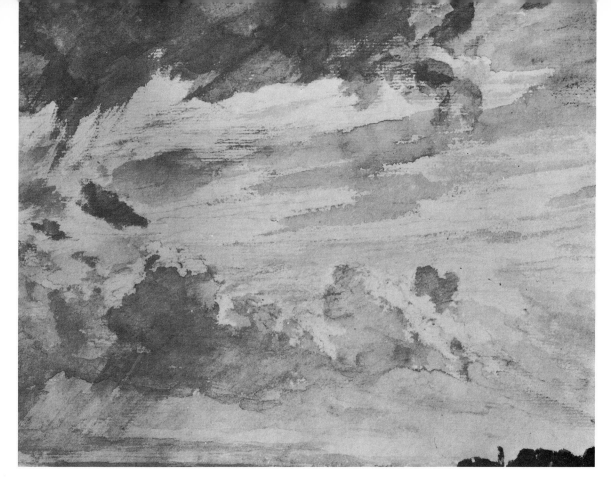

65 JOHN CONSTABLE (1776–1837), *Study of Clouds Above A Wide Landscape*. Pencil and watercolour (190 mm × 229 mm) Victoria and Albert Museum, London

Then observe how each mass of cumulus cloud bank has been conceived as a separate entity, and then how they all follow diagonal perspective lines back over the sea's surface. The near cloud bank on the left has been made darker so that it carries forward in atmospheric perspective. The foreground has been brought completely forward by the use of the darkened boat, fishermen and nets. One fisherman has, however, been left light to contrast with the others and he *jumps* forward. Constable has established the edges of the cumulus cloud softly with a brush line so they do not break up the sky's atmosphere. The sea is conceived as a flat plane receeding to the horizon; here and there a ship marks out this flat plane. Finally, it may be noticed that some ships are hull down on the horizon, and therefore the suggestion is made that the sea surface follows the curvature of the earth and still exists beyond the horizon even though we cannot see it.

Cloud studies

A fact that one has to grow used to when drawing clouds, is that they move, not only that but they also change their shapes under pressure from the winds and the atmosphere. For this reason a cloud study will often have to be finished from memory. The sky in CONSTABLE's *Brighton Beach* study, although undoubtedly drawn quickly, would still have been completed from memory. The sky in *Rhyl Beach* by COX was also completed from memory. However, once the general principles of cloud construction have been learnt, by sketching them at various times of the day, and in different seasons, it is possible to invent fresh forms from the imagination. Because their change of shape and proportion is so constant in nature, they may be manipulated freely in pictorial composition. I do not believe that it is possible to invent a cloud shape that, sooner or later, could not be seen in nature.

There were periods in the lives of both Turner and Constable when they devoted themselves entirely to the study of skies and clouds. These periods served a two-fold purpose: they acquainted them with the

77

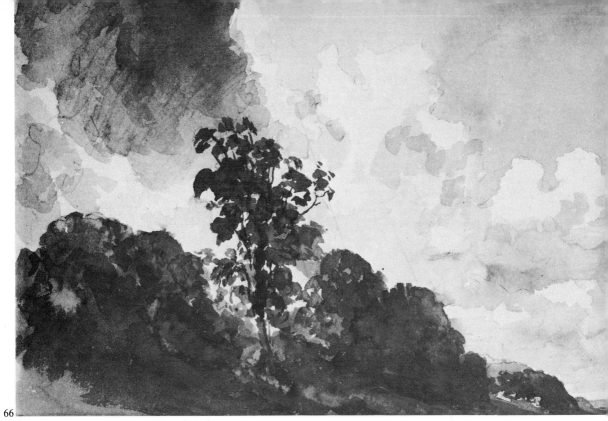

66

67

general construction of many cloud forms and at the same time stocked their visual memories with a repertoire of images which they were able to use freely in later work.

Each sky that we draw can be an exciting arrangement of forms and directions. Before starting drawing, spend a short while observing which way the clouds are moving, how many layers there are, and what their general shapes are like. Because clouds do move, it is not possible to estimate their proportions accurately and so once you have decided to draw, their disposition across the sky must be stated very quickly. Once you are set on capturing a sky you cannot rest until it is complete.

66 John Constable (1776–1837), *Study of Clouds and Trees.* Watercolour sketch (168 mm × 254 mm)
Courtesy of the Trustees of the British Museum, London

67 *Late September.* Pencil and watercolour (520 mm × 625 mm)

68 John Constable (1776–1837), *Folkestone ?1833–5.* Pencil and watercolour (114 mm × 184 mm)
Courtesy of the Trustees of the British Museum, London

Constable's watercolour drawing of clouds shows how rapid activity is demanded from the hand to capture the effect of a quickly changing sky (65). This is an example from a series of studies he made in 1830. Luckily for us the date is not important: it is timeless and remains forever young and fresh. This study was made during a late summer evening. A rain shower falls from the more distant clouds and a darker cloud looms threateningly overhead. Notice how the contrast of movement has been made between the long drawn out higher clouds and the lower cumulus ones. The watercolour was kept fairly dry in the brush and drawn rapidly across the paper to suggest movement. Take special note of the wind torn cloud in the top left. It is so freely handled and yet so perfect in what it says.

Here is another of Constable's cloud studies made in the same year as the previous one, and probably sketched from a window of his house in Hampstead (66). Observe in this drawing how the artist has achieved the effect of the high banked cumulus clouds and their perspective. They move diagonally across his line of sight from top left to

69

70　J M W Turner (1775–1861), *Sailing Boat in a Storm*, 1830. Watercolour vignette (135 mm × 145 mm) sheet (215 mm × 293 mm) Courtesy of the Trustees of the British Museum, London

bottom right. The near one in shadow suggests the clouds were also above and behind him. The white caps of the clouds are suggested by leaving the white paper bare.

Cumulus clouds can be good subjects for the practice of pencil work. When I wish to make a complicated study where the main part of the subject is the sky, but also includes boats or waterside buildings, I use mixed materials. I start with either pencil or wash, and then build up with softer pencils, *Conté* crayon, soft crayons and watercolour washes. This type of mixed media drawing will generally take me about two hours to complete.

The cargo ship leaving port was started in pencil and then was drawn entirely in a full colour range of soft crayons (67). In this scene most of the sky was a clear blue, with just a few isolated clouds. The ship made a dark silhouette against the bright sky, and the clouds were floating across the sky quite slowly. I used the clouds in the top right hand corner to provide lines to lead the eye down to the ship. I made several quick pencil notes of the ship and

referred to them later as the drawing progressed. The drawing was completed in a range of different blues, black, grey, with slight touches of red, yellow and green. I wanted to catch the almost stationary effect of the clouds and the shape of the slow moving ship picking a path down channel to the sea.

More drama from a Constable sky (68). Drawn in Folkestone in the same year as the previous one when on visits to his children there in 1833. It is a watercolour work that was probably added to in his studio sometime during the following two years. The sky is given two-thirds of the paper space and is Constable's main motif. It shows low cloud giving heavy rain at intervals; the cloud being open in places allowing the passage of sunlight. There is a rainbow in the distance. It comes from the hand of an artist well able to orchestrate the effects of nature into a picturesque composition. The big overall movements are worth study, the firm horizon line provides an abrupt right angled contrast to the ships' masts beyond the harbour mole. Against this are played all the lovely loose diagonals of the cloud movements. For final delight little pieces of light

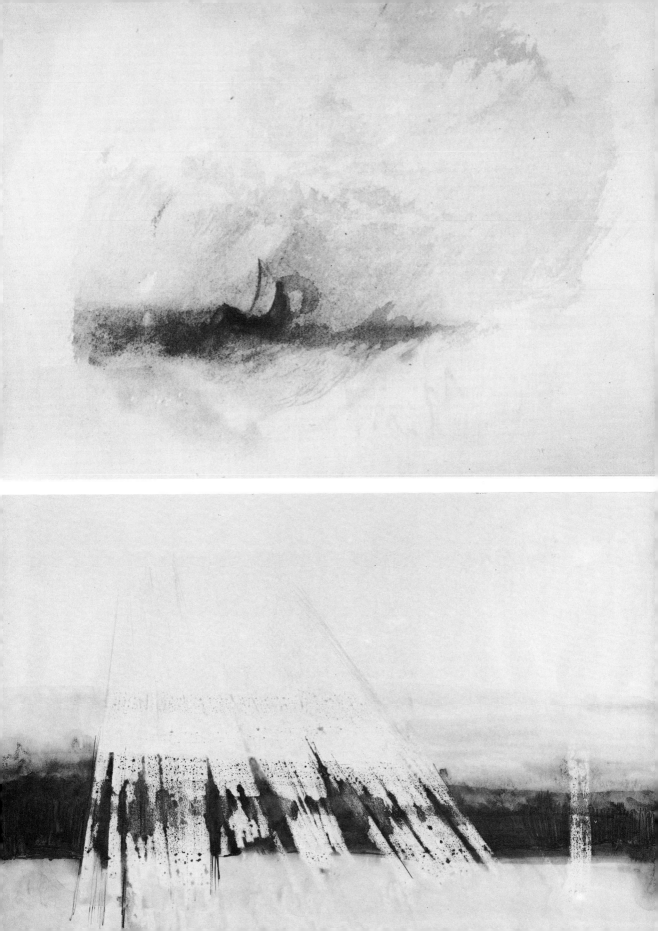

and dark are played across the horizon with cliff tops, harbour details and sailing ships at sea.

Rain leaving cloud can be a subject in its own right (69). The rain can be seen making a definite linear pattern if you watch for it. I try and observe this phenomena as much as I can, as I do all other types of sky effects. Two good vantage points are either the tops of hills or looking across a wide bay or estuary from high ground. I find it is necessary sometimes just to go out and look without drawing.

I used 3B and *Black Prince* pencils to draw this rain cloud. It was completed away from the scene. This particular cloud was observed from across a bay, the rain falling on the hills opposite. The curly, jagged shape of the cloud contrasting with the explosive quality of the descending rain was a most compelling sight. There was a strong light behind the rain cloud although where I was standing was in deep shadow from cloud overhead.

Again there is little visibility in this wonderful sketch by TURNER of a sailing boat in a storm (70). It is one of a number of small sketches commissioned from Turner in 1830 to be used as embellishments for a poem. Although incredibly small it is totally absorbing and has the same fascination and hardly less power than one of his larger works. It is all built on one certain diagonal movement.

Light breaking from cloud can appear somewhat similar to that of falling rain (71). I have made numerous studies of this cloud and light effect. I experimented with colourless greasy crayon or wax. I drew on the light rays with this material and then passed across it with monochrome wash. The light rays can be picked out finally with a pencil, pen or crayon.

Night skies are difficult for there are no definite features with which to identify (72). This drawing was made with black and blue inks with a brush. The passages of moonlight on the clouds was produced by drawing them on the paper first with white wax and then painting over with black ink. The light boat shapes were made by the same method. I left a thin white line at the horizon to separate the sky from the sea. I mingled the blue and black inks in long strokes to suggest the presence of clouds. Wherever there is a little light then what there is must be preserved and used to the full. The application of clear grease or wax is a method which allows small points of white paper to be saved and thin strips or chinks of light to be created. Placed carefully they will give a sharpening and brightening effect and provide an interest of their own.

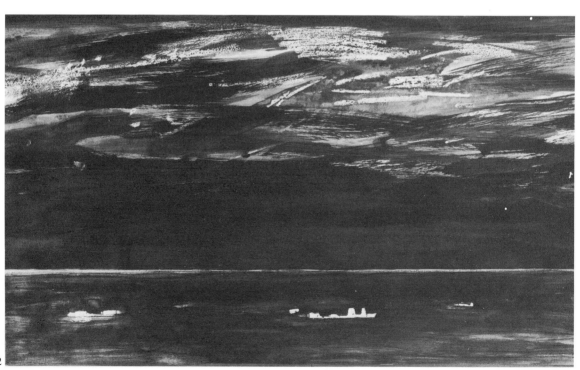

72

Boats

Boats and sketch book work

One of the most successful ways of describing a boat is to draw it. You will find that the beauty of a boat's hull can be captured by line. Try from the beginning to give a sense of roundness to the hull, exaggerating if you can the curves of the shape (73): almost caricaturing the shape to give a 'tub-like' quality. By 'tub-like' I mean the type of hollow form that would result if a wooden cask was cut in half through its height. Of course this would make a clumsy boat, but some may find it a useful basic form to have in mind to fire the imagination. From it more graceful lines can be developed to construct the tapering form of a typical boat, finishing with stem and stern shape. You can draw these lines quite freely to represent the curved timbers of its sides; you can also try drawing sections round the boat, going down one side and up the other. Do this very freely, particularly if you have not done much drawing before. Let your lines build up. If you have drawn two lines and they appear too far apart, and you do not think the eye can jump the gap and relate them, then draw a third line between them. Do not attempt shading until much later. Shading will not give you shape. Shape must be *felt* by lines making curves. If you miss with the first line it will have at least started a feeling for depth and roundness on the paper; follow on with other lines and you will find that the first line does not look so bad after all. Lines of the same sort associate with each other very well and, when there are enough, produce a meaning. One curved line on its own for a boat may not have much meaning, but add others in the same general size and shape and a meaning does start to emerge. When you do come to shading or showing parts of the boat in shadow, start by using more

lines or hatching that fit with your previous lines you used to make the hull shape. We are all used to the camera which produces pictures with fine graded tones. In drawing we can only make a line or small area of tone at any one instant. A drawing has to function by line. Free drawing gives an opportunity to find out how lines can be made to work together to produce the shape we want.

In order to practise sketching go to where boats are moored or beached, and get amongst them so that you get front, rear and various three-quarter views of them. It is better in the beginning to choose a viewpoint where you are surrounded by boats, for in this way their shape and form will be impressed on your mind, and you can look from one to the other to learn more about their construction. Do not think about finish at this stage. Enjoy the boats' shapes and interpreting them. An A3 spiral bound sketch book would be useful for this work. Draw with soft pencils, *Conté* crayon, charcoal or pen. An A3 sketch book contains 420 mm × 297 mm ($16\frac{1}{2}$ in. × $11\frac{3}{4}$ in.) size paper, which is suitable for this type of work.

Boats are ideal sketch-book material. I have chosen four sketch book pages to illustrate the type of approach I use myself. The first (73) was drawn in felt pen and a few ball point lines. I make study sheets of this type from time to time, my only concern being with the simple basic form of a boat, and becoming more fluent in recording it. There are always new shapes to be discovered because boat shapes are adapted to meet the varying local conditions of inshore waters. The shapes were drawn very rapidly, every time I started a line I tried not to waver and was not too concerned about making the lines all join too tidily, although I kept

73

74

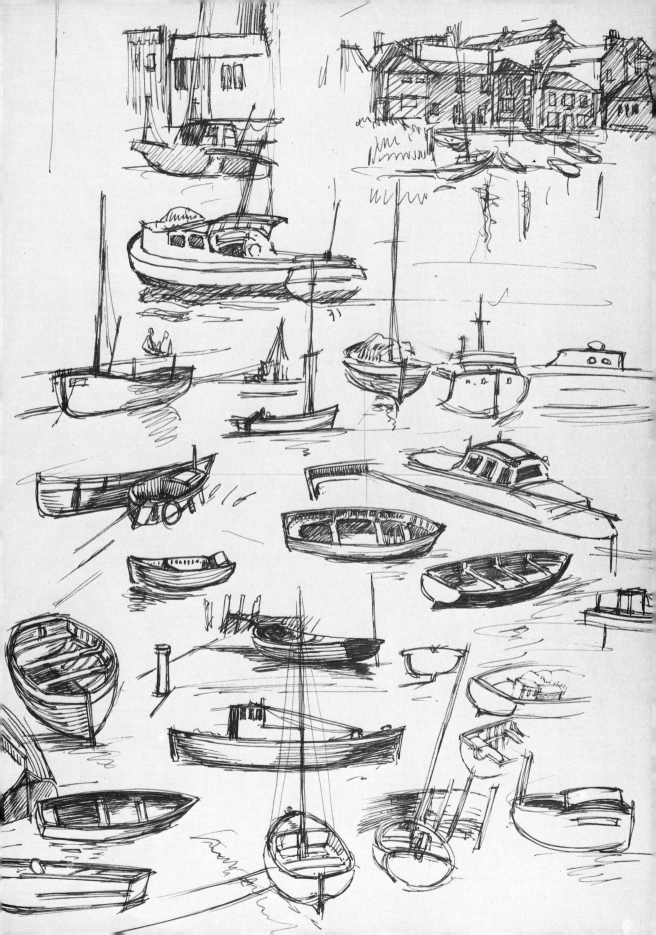

the stem position and the stern shape in mind. When you draw, be motivated by the spirit of the boat shapes and line movement rather than by precision. Try and feel their form and express their hollow construction.

The second sheet (74) was drawn in pen and ink, I used more and more lines to follow the shapes of the boats, and I find drawing like this with a pen prevents me from wavering. If necessary, practise strokes with pen on the side of the paper first. In this second sheet you can see I have drawn other details as well as boat shapes. Stem shapes, masts and rigging, and this is always a good thing to do if you feel like it.

The third sheet (75) I have chosen because it shows a greater variety of boats and boat detail. They were all found in a small harbour and I enjoyed the challenge of the variation in the sup-terstructures. More time was spent on detail, particularly on boat seating and motor cruiser cabins. A view of some houses at the harbour was included spontaneously.

The fourth sheet (76) is a single study of a small motor boat. It was drawn in charcoal pencil, *Conté* crayon and fine felt-tipped pen. This sketch took about twenty minutes. The view from above allowed me to observe the deck shape, and the cockpit with its folding protective hood. My first lines were in light toned charcoal pencil and established the hull shape. Marks in *Conté* pencil were rubbed on to indicate the cockpit shadow and the colour band round the boat's hull.

CONSTABLE's watercolour of *Folkestone Harbour* (77) is a fine example of a pictorial composition resulting from an artist being amongst boats. For this drawing Constable moved inside the harbour mole and made a composition from small boats stranded after the tide had gone out. The boats lean in all directions and the artist obviously felt they were asking to be drawn. Probably the pen drawing was made at the scene and a great deal of the watercolour added later for there is a colour note 'all grey' just above the stem of the boat in the foreground. This drawing is remarkable for the deft manner in which the artist has drawn the boats and also for its clear realisation of space. Without question, the mud bank and the low water in the harbour are the start of a ground plane which stretches back to the horizon. The position of the fishermen on the bank and the positions of all the boats and the mole itself all act as markers for distances into the picture, and the boat in the

76

foreground has a convincing 'tub-like' quality. This drawing also gives a good indication of the amount of detail which is acceptable in a drawing. The detail is not over profuse: too much detail is likely to destroy an atmospheric effect. Too little detail and a drawing may lack conviction. A little visual gem in this drawing is the cumulus cloud with cliffs in sunlight below at the extreme left of the drawing. Look from the fishermen on the left through the boats to the cliffs and cloud beyond. This little piece of the drawing is truly a wonderful representation of seaside atmosphere and its light and air.

Ropes, tackle and moorings

Whenever possible, time should be given to sketchbook studies of rigging; mast arrangements, yards and booms; anchors and moorings. It is not necessary to understand all the mechanical aspects of these devices, but enough should be drawn from time to time to ensure a certain depth of understanding of the technical equipment and accessories associated with boating and sailing. Any visual aspect of a boat's detail you use should have the ring of truth about it, and of course if you wish to undertake the portrait of a boat or ship all the detail shown must be accurate. For general work a broad knowledge of the principles of masts, yards, sails, metal hoops, metal and wood blocks, and systems of cordage will always be of service. Rapid sketches of boats offshore, for example, will be easier and improved because of it. Principally one needs to be aware of which rope is passing behind another, and how and where sails and ropes are attached. To give guidance on this I have explored my own sketch books and have detached sheets of studies I have made at different times of boat tackle.

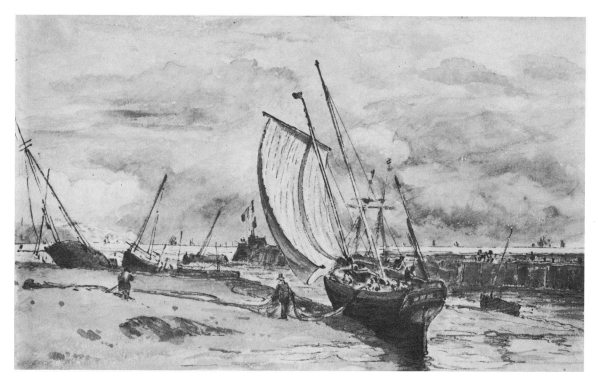

77 JOHN CONSTABLE (1776–1837), *Folkestone Harbour*.
Watercolour with pen outlines (127 mm × 216 mm)
Courtesy of the Trustees of the British Museum, London

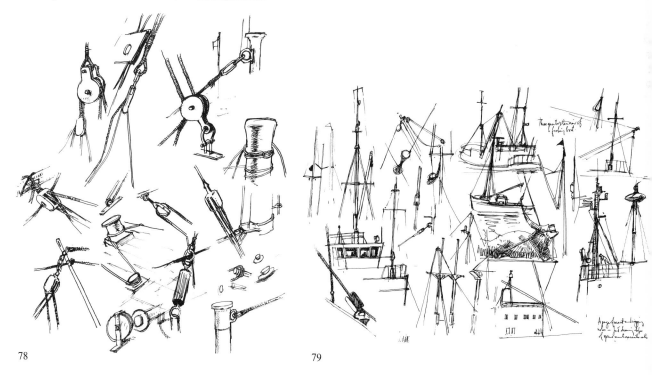

78

79

87

The first (78) shows a number of pen and ink studies of blocks, metal hoops and ropes. To do this I walk round a mooring bay and draw whatever detail of linkage or blocks I can see clearly. The aim is to become more aware of the different shape and proportions of blocks and pulleys and to understand how ropes were threaded through them.

My next sheet (79) shows a different interest. On this occasion I made a study of masts, cross yards, spars and aerials. These are drawn in pen and ink, and the choice of subject matter was quite random. Each sketch took a few minutes.

The third sheet (80) was done on an occasion when I became fascinated by a large coil of rope slung over a boat's rail and made an attempt at following each coil of rope round and through the others. I then turned my attention to a rubber tyre hanging on a boat's rail acting as a fender, finally I drew the boat's navigating and steering cockpit with protective hood. There are also a few other boat details and shapes on this sketchbook page. Sheets like these three provide a great deal of information and are worth persevering with.

The three following sketchbook sheets (81, 82 and 83) are the work of JOHN JOHN CONSTABLE. The first (81) you would probably never have guessed was by Constable and that, I think, proves the value of sketchbook studies. They are quite often without personal style because they are not conceived as pictorial works, rather they are working notes. The second (82) does have some pictorial value, enough of the derelict boat behind the anchor the boat top and spare timber lying about make a pictorial composition. The third sheet (83) has an anchor, which leads to the conclusion that Constable was intrigued by the sculptural form of an anchor; and they certainly are interesting objects to draw. The drawing at the top section of the sheet belongs to his *Brighton Beach* series and is one of a large number of beach pictures he sketched in this format. The beached boats, one with a sail rigged, is a separate study in which he has recorded his impression of the boats, their masts and yards and the group of fishermen sitting on the beach. This is a composition note that would be reserved for future possible use. Once you have made a regular habit of keeping sketch books there is always the chance of discovering useful pictorial material in them, at a future date. I cannot remember all the drawings in my sketchbooks, but I know they are the place to go when I am lost for an idea or need information.

Beached boats

The last sheet of studies by Constable of boats drawn up on the beach is a favourite subject of marine artists. Generally when a boat is beached or moored near a beach at low tide, nearly all its shape can be seen. Often they are not upright but lean to one side, their rigging, yards and sails spilling over the side, or they are left stranded by a bank or groin with bits of equipment in or beside them. Two studies, one by SAMUEL PROUT (84) and another by CONSTABLE (85) give a good start to the consideration of this type of composition. The Prout catches attention at once because of its unusual presentation of stranded boats and sail. The sail shapes and the fishing net hanging over and above the boats give immediate interest to the drawing, and occupy important areas of the composition. The composition appears to be accidental but the artist has used a series of dark notes, as sail shadows on blocks and on fishermen's hats and leggings, to focus the eye on varying varying parts of the drawing and keep it on the scene. This drawing was made with a soft pencil and then built up with a monochrome water colour wash.

CONSTABLE's boat on a beach (85) was drawn in ink and then completed with watercolour. This is a little more free in execution than the previous studies. The scudding clouds and some movement in the water suggest a breezy day, and the masts and rigging of the three stranded and leaning boats provide oblique lines which heighten the feeling of movement. The beached boat in the foreground is worth studying, and perhaps copying it a few times into a sketch book could be useful. It is an attractive three-quarter view of a hull and the shape and form is very clear.

Again I have been through my sketch book looking for approaches I have made at various times on the topic of beached boats, or boats left at moorings. Here are four sheets on the subject taken from a small (149 mm × 202 mm) book (86). All the sketches took from five to ten minutes each. They were drawn with my old pen, and the wet ink rubbed with the end of my finger to gain tone areas. They show the need to keep sketching materials with you

81 JOHN CONSTABLE (1776–1837), *Studies of Fishing Gear near Brighton*. Pen, pencil and grey and pink wash. Sketch-book page (181 mm × 264 mm)
Victoria and Albert Museum, London

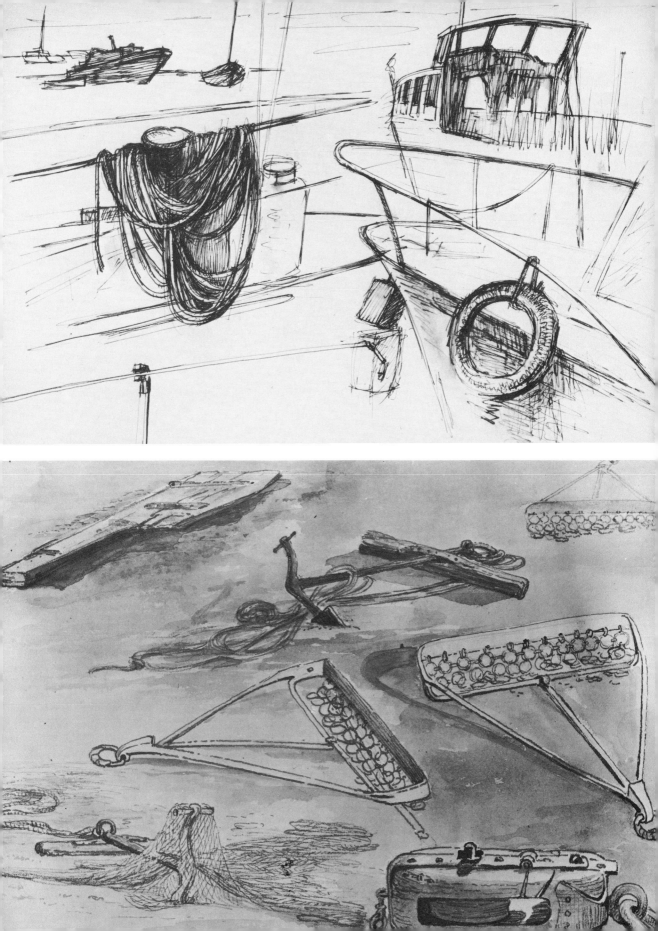

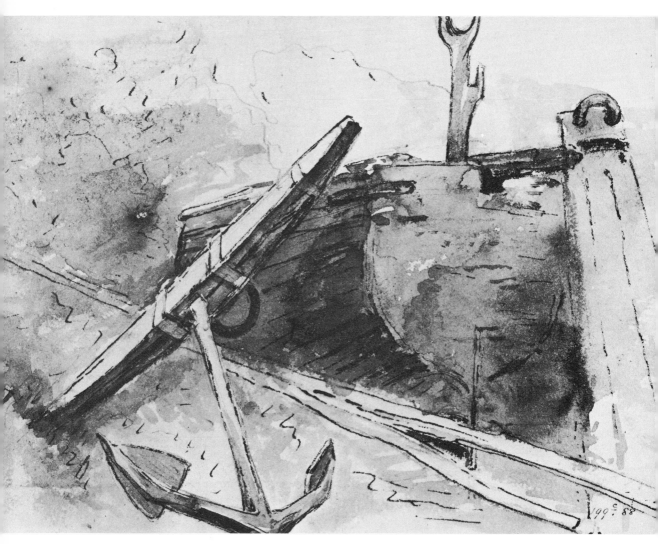

82 JOHN CONSTABLE (1776–1837), *Derelict Boat and Anchor
Brighton*. Pencil, pen and grey wash (115 mm × 185 mm)
Victoria and Albert Museum, London

83 JOHN CONSTABLE (1776–1837), *Studies of the Beach at
Brighton*. Pencil, pen and grey wash (181 mm × 264 mm)
Victoria and Albert Museum, London

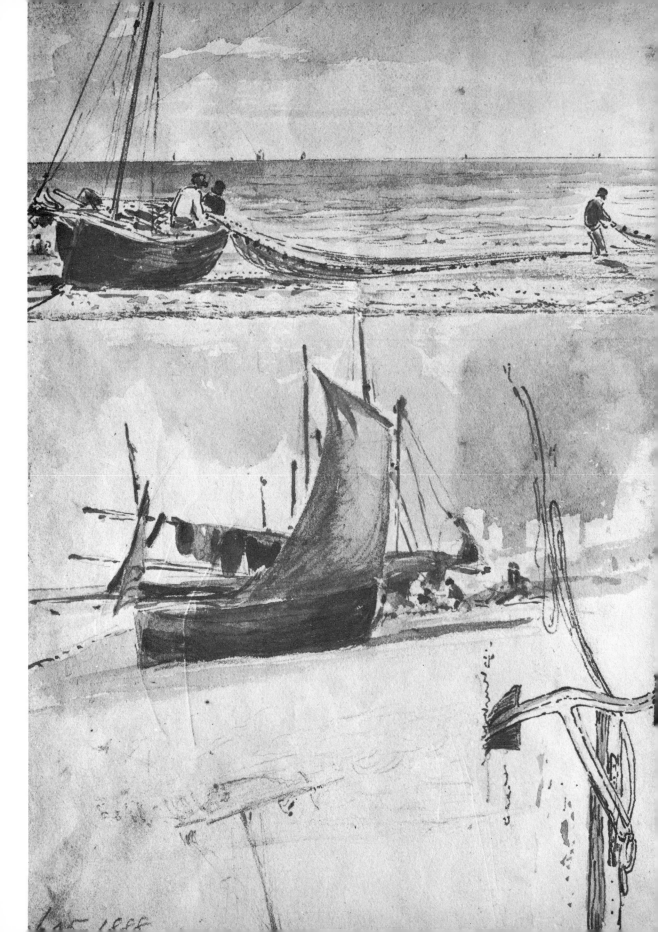

84 SAMUEL PROUT (1738–1852), *Study of Fishing Smacks*.
Pencil and wash (114 mm × 171 mm)
Victoria and Albert Museum, London

85 JOHN CONSTABLE (1776–1837), *Coast Scene, Probably near Brighton*. Pen and grey wash on rough paper
(268 mm × 336 mm)
Victoria and Albert Museum, London

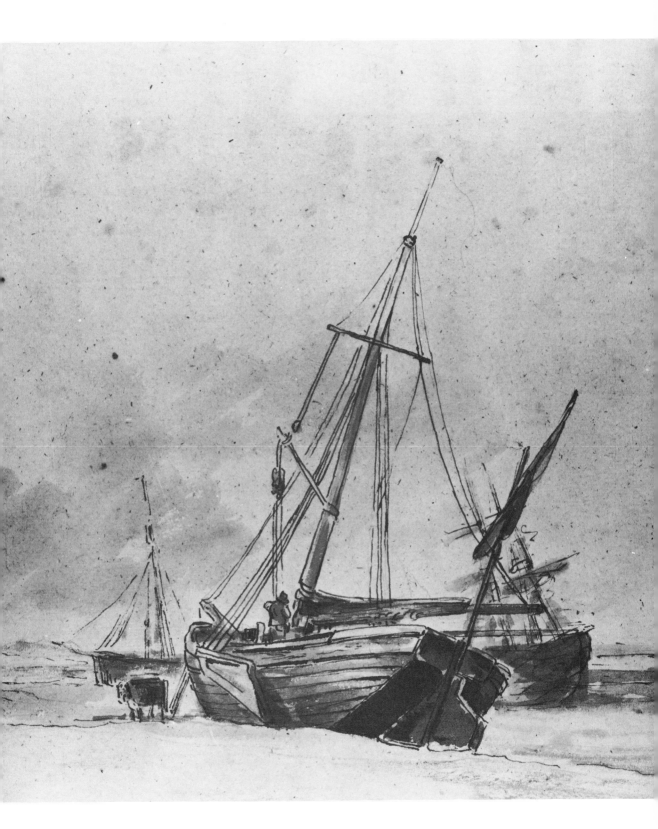

93

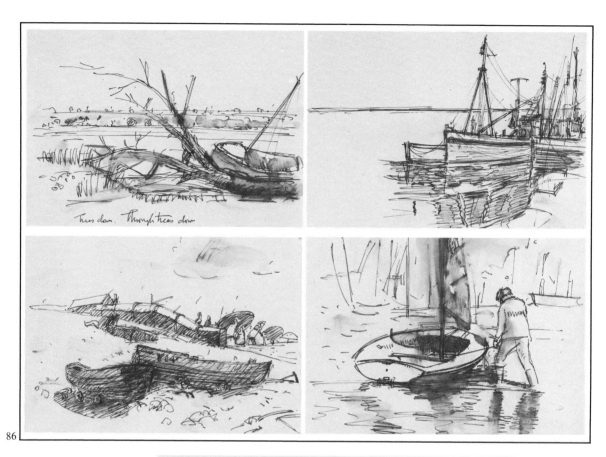

Trees down. Through trees down

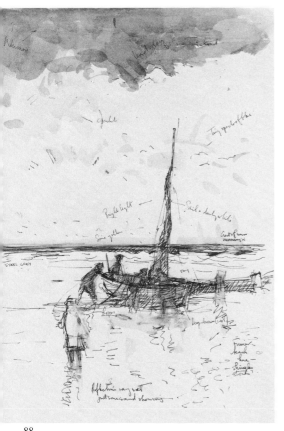

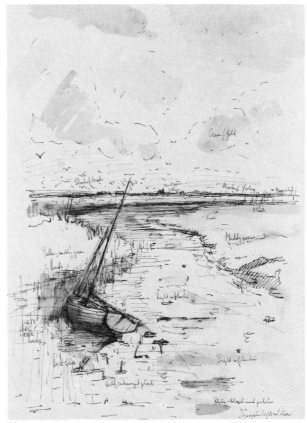

because you never know when you may need them; so be prepared to see a subject and have a go at it.

This is a drawing of people tidying up their moored boats on a summer evening (87). The paper is A3 and the medium is pen and ink. The drawing took about thirty minutes. I was attracted by the sharp silhouettes of both the people and the boats. I remember I increased the density of the cross hatching later to get the final effect.

Two further sheets of A3 size come from a sketch book that held hot-pressed, very shiny, white paper (88 and 89). The drawings were made with pen with the addition of monochrome watercolour. They are taken from a series of drawings I made at a river mouth and estuary. They were all very quick sketches, which have been pulled together with a wash. There is a number of written notes on the first drawing showing fishermen unloading their boat. Jottings about shape, tone, texture or colour on a sketch are most useful. Just a few words written where necessary often helps to recall an important quality or detail later. The sketch of the deserted

boat also has little notes on it. I have never used these drawings for a more complete work yet, but because of the notes it would always be perfectly possible to do so.

The study of fishing boats (90) was made on A2 (420 mm × 594 mm) paper. In pen and wash it was a lengthy drawing. Much of the time was taken up in establishing the proportions and below eye level situation of the nearest boat. It has become one of my more useful drawings because it gives important information on the size and shape of this type of boats' wheel house and hatches, and the position of its masts.

The motor cruiser study I worked on from memory (91). One wet summer afternoon I watched from a bridge as some boat owners fastened covers over their boat cockpits in the rain. I tried in the drawing to show the rather brightish light as well as the rain. The drawing was on A2 paper in pen, ball point and wash. This drawing was great fun and gave good practise in hatching textures.

My last example of a beached boat is a more

complete work (92). It was made from some notes on the spot and completed in the studio. It is both a boat and sea study. The preliminary drawing was made in soft pencil and then in pen. Ink and watercolour washes were used to complete it. The boat seemed forlorn on a bare coastal strip, yet it offered a strong pictorial motif with the wave breaking on the rocks and the line of breakers moving in towards the shore. The waves breaking on to the bare rocks were thrown up quite high into the air, the water splintering as it rose. To try and catch the glass-like effect of the splintered water I drew with white *Tipp-Ex*. The whole scene seemed ashen in colour so that the varying tones of the blue-black ink washes were very suitable. I deliberately left areas of white paper throughout; for the clouds, parts of the wave line, the breaking water and the rocks in the foreground.

One more look at CONSTABLE's sketching on *Brighton Beach* (93). This study of beached fishing boats is quite a small drawing, yet appears quite large because of the attention Constable has paid to detail and perspective scale. The height of the figures at the water's edge. the size of the various boats and their relationship to the chain pier has been carefully observed. The boats seen large in the left foreground also force the spectator to look more deliberately into the detail of the seascape on the right. Another attractive quality of this drawing is the richness of the pen lines which have been drawn very boldly on a rough grained white paper. Constable made a number of studies of the old chain pier at Brighton and finally included it, and other information from his *Brighton Beach* sketch-books, in an oil painting now in the Tate Gallery, London.

Moorings and harbours

Moorings and small harbours are full of interest for those who like boats and sketching. There are always new types of boats to see and a never ending supply of fresh compositions. A busy harbour will see the arrival and departure of many boats during the course of the day, but even if this does not happen, fresh compositional arrangements will

90

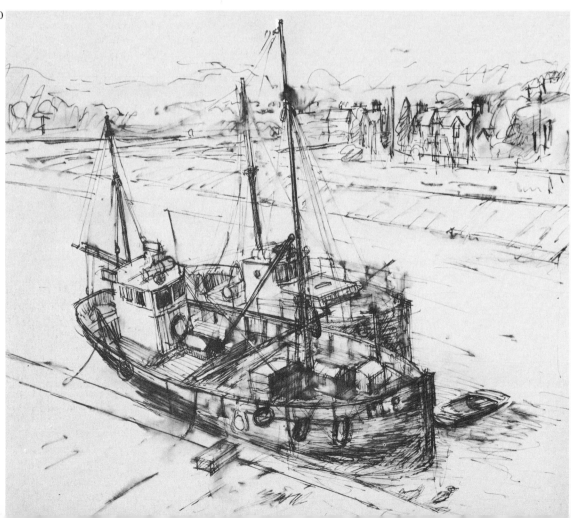

occur as boats turn at their moorings in a wind, or rise and fall on the tide. Four more small sketch book studies from my small books (149 mm × 202 mm) show some possible arrangements (94). Three of the studies have a high horizon line and the horizon line in the bottom right study is about half way up the paper. An horizon line half way or above half way will often prove the most useful. This arrangement gives plenty of water space for boats, jetties or harbour walls and other details. A low horizon line is excellent for the presentation of one large ship which can then be drawn as if it is towering above the spectator. In all these sketches I have made a statement about the light and shade, the shade scribbled in with numerous pen lines, cross hatched where I wanted a darker tone. For sketches of this nature to have a pictorial value they must have a theme or story line. This helps to hold them together and provide a visual focal point at the same time. Viewing these sketches clockwise, the themes for these four sketches were: cluster of small boats seen against the setting sun; moored boats against a bush-lined bank; moored boat at low

water with paddlers; and man watching sailing boats.

The following seven studies explore the theme of boats at moorings. They are attempts with a variety of drawing materials to present particular visual aspects of scenes which had caught the eye. The first shows boats on mud flats with long mooring lines stretching to the bank (95). This was drawn rapidly in *Black Prince* pencil. The upper portion of the drawing shows the far bank which had houses and trees on it and small coastal vessels in front. However, I blocked all this in with rapid dense pencil work and concentrated on the stranded boats in the foreground; there was some water over the mud and the whole effect was of a very shiny surface with some reflections. Most time had to be spent on the boat shapes so that something of each of their individual characters was shown, and the final few minutes were spent on the mooring ropes. The next study was made at a ferry landing stage in a small harbour (96). It is quite a complicated scheme and needed a careful planning stage. The planning was in pencil although the sketch is in pen and ink and

91

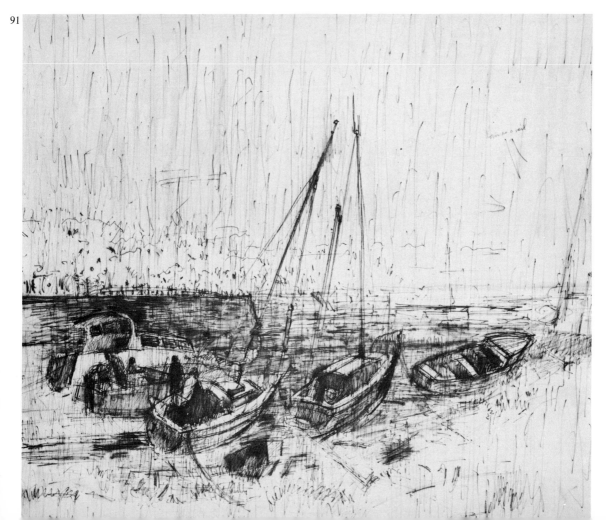

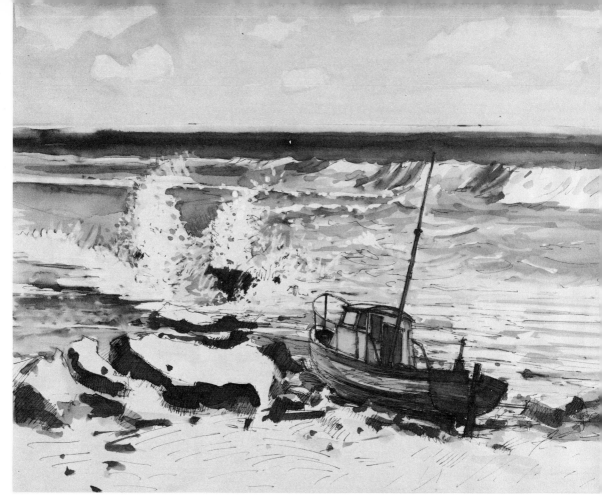

92 *Beached Boat*. Pencil, pen
and ink, monochrome wash
(490 mm × 620 mm)

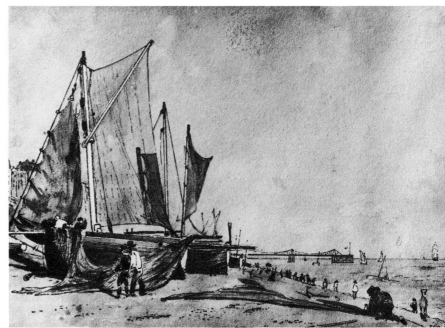

93 JOHN CONSTABLE
(1776–1837), *Brighton Beach,
with Fishing Boats and The
Chain Pier*. Pen, pencil and
watercolour
(178 mm × 259 mm)
Victoria and Albert Museum,
London

94

95

monochrome wash. For the town and jetty across the harbour I used simple tones with monochrome wash. Generally speaking, one has to be selective about the use of detail in drawings. Some parts have to be reduced to simple tones or empty areas so that others may achieve a particular prominence. In this study there were really four separate visual events. The man in the small boat with the outboard motor; the boat crossing the harbour; boys tying up their rowing boats; and the moored motor vessel in the foreground. The main aim of the drawing was to capture the sunlight on the buoys and the moored vessel. Most of the preparatory pencil drawing was in the foreground, where a great deal of proportion and shape checking was required.

The next drawing (97) was something of a marathon event. It is a view of a marina full of small sailing and motor boats. The drawing took an hour and a half. I started by drawing the boats in the centre and then gradually indicated the town behind; more boats and town were gradually added. It was intended to be an extremely bright scene and

so there was no need to use much tone or wash. I drew with a fountain pen and just re-drew fresh lines if I found previous ones were wrong, and in fact this helped to create a sparkle of brightness which was there.

The MONET, drawn in black crayon on white scratchboard, shows boats moored near Rouen (98). It is such a familiar scene, so beautifully presented, that the artistry could easily be missed. The main subject is the effect of the light on the different parts of the scene, not the parts themselves. Throughout Monet was aware of a strong light which, silhouetting the boats and poplar trees, shone on the water surface, and lit the sky and the fronts of the distant houses in Rouen. The black crayon has been used with wonderful effect to gain the silhouettes. It has been scrubbed on quite forcibly. Revel with me in the freedom of the crayon technique. It is so unaffected and direct. You will not see the almost scribbly character of the drawing unless you look closely; Monet was able to scribble down tones which are correct atmospherically for

96

any position in a scene. One therefore never sees less than a whole effect.

The TURNER *Fishing Boats and Harlech Castle* (99) has the same still serene quality as the Monet. But it is a drawing made with a brush in tones of greyed brown. It is typical of the many studies he made on sketching tours of castles and their surroundings. The direct brush work has an almost Chinese quality. As in the Monet, the suggestion of light Turner obtains is important for the life of the drawing. Dark sails by contrast show up a light and luminous sky over the horizon. Again it is a matter of making silhouettes; and because of the broad and simple brushwork one never sees less than a whole effect. It is useful to study the Monet and the Turner together, and see how each artist, although working with a different drawing material, has achieved an overall impression of breadth and simplicity.

The next study (100) shows fishing boats moored in a small harbour. I drew this in black crayon on a toothed paper and used a little white ink to clear out areas that I wanted re-established as whites; it was a form of rubbing out. Here I wanted to record the pattern of darks made by houses and boats and the lines made by a strong tide coming in. The crayon worked well on the rough paper, and there was a white grain left in every black mark.

The example shown in colour plate 3 is sunny and serene. Fishermen examine their catch and check over tackle under a Mediterranean sun. This drawing was probably made near Corfu where GIALLINA practised for some time. It suggests warmth and the still calm restfulness of a summer day. The drawing was made in 1895 from an everyday scene in the region. As a piece of realism it was no longer revolutionary, as it might have been in 1855, but still something of a novelty. Giallina accommodated to his market and produced attractive pieces that were not too artificial or soulless, and which contained a spirit of poetry. His own personal vision was strong enough to protect him against the worst prejudices of his day, and allow him to be so affected by nature that he could produce individual works of this quality.

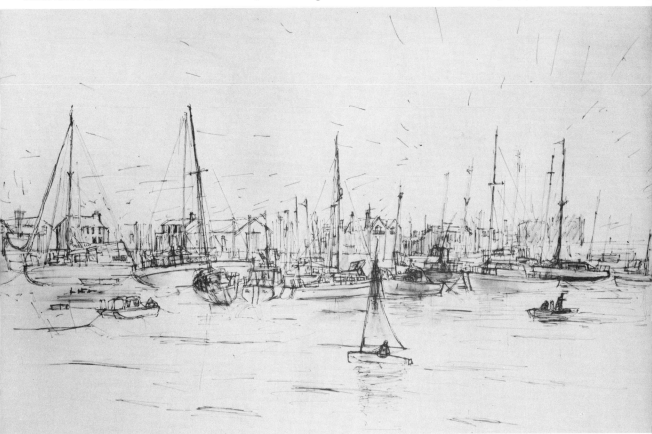

98 CLAUDE
MONET
(1840–1926), *View of
Rouen*. Black crayon
on white
scratchboard
(327 mm × 499 mm)
Sterling and
Francine Clark Art
Institute,
Williamstown,
Massachusetts

99 J M W TURNER
(1775–1851), *Fishing
Boars and Harlech
Castle*. Monochrome
wash
(248 mm × 311 m)
Courtesy of the
Trustees of the
British Museum,
London

100

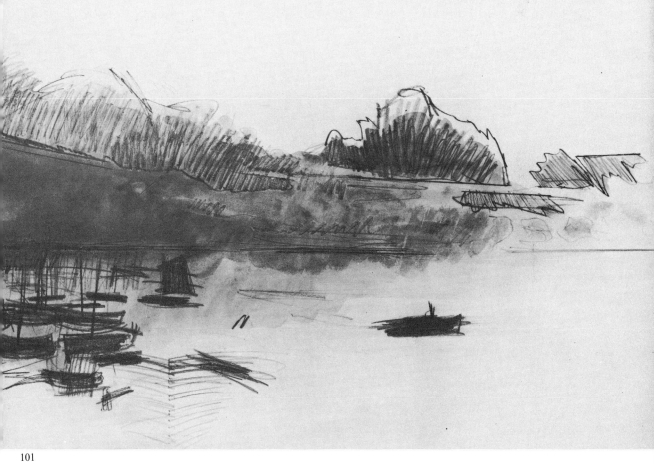

101

102 D S MacColl (1859–1948), *St Catherines Quay, Honfleur*, 1906. Pencil and watercolour (230 mm × 305 mm) By courtesy of the Trustees of the Tate Gallery, London

103 Robert Austin (1895–1973), *Palaces, Grand Canal, Venice*, 1925. pen and ink and pencil on sugar paper (360 mm × 495 mm) By courtesy of the Trustees of the Tate Gallery, London

The boat and the fishermen on the calm water are like objects on a stage, the clouds and mountains behind forming a backdrop. What is needed to extract interest from a quiet scene such as this? Well, we must fall in love with the subject; and in at least two particular ways. First there must be an overall compelling impression; and secondly, there must be the possibility, that by the use of detail, a composition can be made that has some quality of liveliness and animation.

Giallina has succeeded in getting all the parts of his scene into context by using his impression of them being bathed in warm sunlight, and his particular rendering of a pale blue sky, summer cumulus cloud and a heat haze over the mountains help bring it into effect.

For animation, he uses all the available detail. The rocks, the construction of the boat, the clothes of the fishermen, the fishing equipment and water and cloud texture. And perhaps it is in the detail that we can detect the Victorian wishing to make everything appear *real*. Nevertheless, it all works together because it is true to the artist's own perception, and it is the quality of truth which gives the drawing its particular charm.

For the final example on the mooring theme I have chosen a more abstract study (101). It was drawn in *Black Prince* pencil at first, and then charcoal pencil was used; finally blue gouache was added to the sky with some other pale blue washes throughout. The drawing was an attempt to capture very rapidly the shapes of the moored boats in relation to a dark cloud bank moving towards them. I worked very rapidly and left half of the paper surface untouched. I wanted the impression to be as fresh as possible.

MacColl's *St Catherine's Quay, Honfleur* (102), is a study of a small port amongst old houses. The drawing was made in pencil and then watercolour added. The scene makes a busy little composition; the artist has, however, controlled the detail of the attractive houses by only allowing it a subordinate role within the total shape of all the buildings which are simplified with a half tone wash. The masts of the boats provide a focal point by forming an interesting triangular shape just a little to one side the picture centre.

Austin's boats on the *Grand Canal, Venice*, shows a different approach to the drawing of the juxtaposition of boats and buildings (103). The drawing was made in pen and ink and pencil. The study of both boats and buildings is in very careful

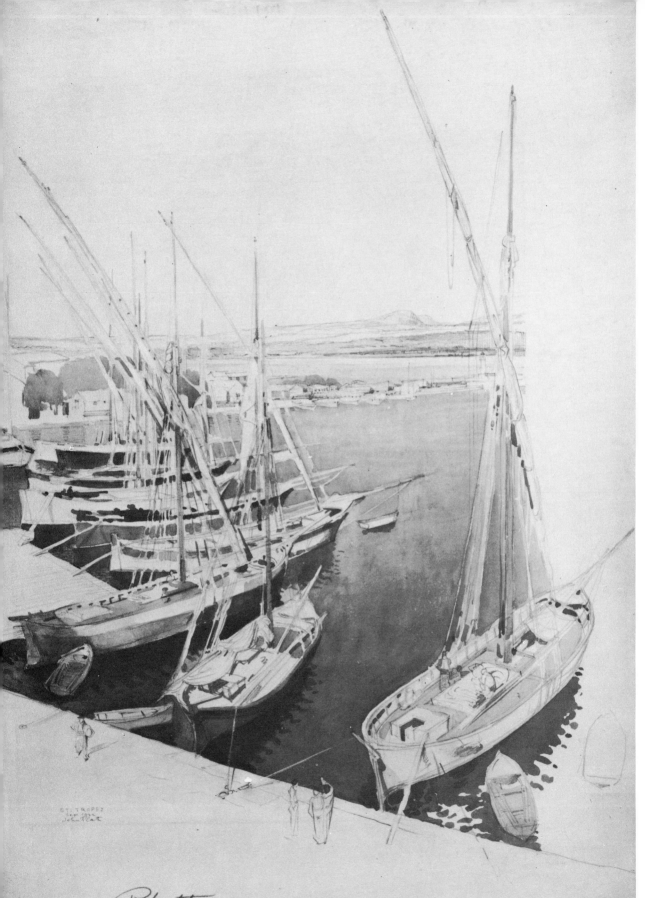

ST. TROPEZ
SEPT 1922
John Platt

9875. Platt.

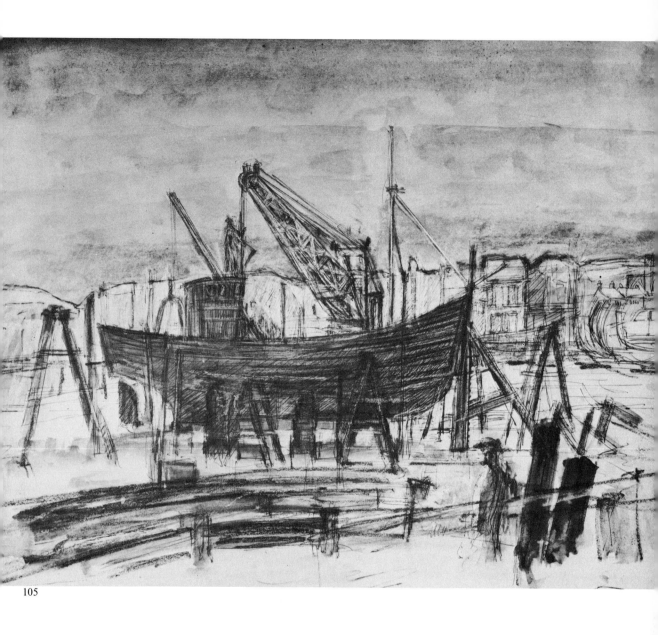

105

104 JOHN PLATT (1886–1967), *The Port of St Tropez*, 1922.
Pencil and watercolour (470 mm × 325 mm).
By courtesy of the Trustees of the Tate Gallery, London

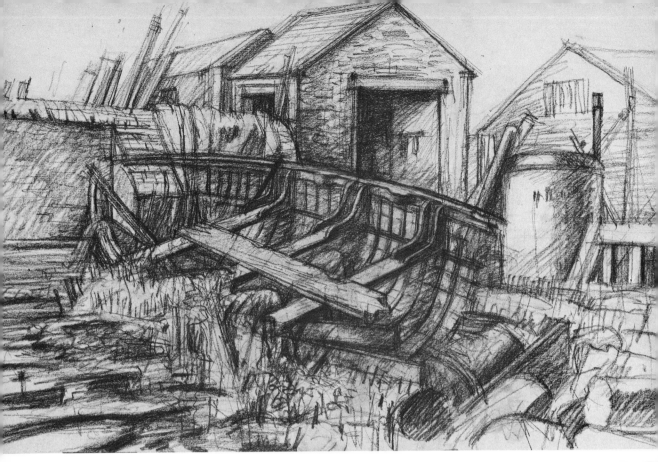

106 *The Broken Boat. Conté* crayon
(415 mm × 640 mm)

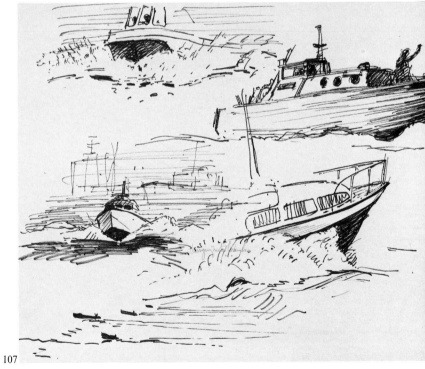

107

108

detail. Each separate building or boat is determined by its exact shape and proportion. No toning down process has been used to lessen the visual priority of any part of the composition. The equal response the artist has made in line to every part of the scene, gives the drawing a unique quality. It is both placid and remote, yet full of stimulating visual detail.

A view looking down into boats in a harbour can be interesting and rewarding (104). Seen in this way the curved sides of a boat are attractive, as is the almost plan view of the deck shapes from stem to stern. JOHN PLATT's perspective view of the port of *St Tropez* contains precision drawing of boat forms seen from this point of view. In the foreground one is invited to look down onto the boats deck section, and looking into the drawing to the middle distance one can see the side sections of other boats. The boat's masts make a series of tall perpendiculars which take the eye soaring up the paper. The masts are crossed obliquely by long yard arms which balance against the directions in which the boats are pointing. The artist has used the watercolour washes very selectively. The sea is in a middle tone blue which shows off all the boat shapes, and then either a deck shape or side shapes have been painted on each boat, so that these two parts of their structure can be distinguished one from the other. Nothing is fudged, all is clear and distinguishable.

Repair and scrap yards

Repair yards and scrap yards in harbours offer many opportunities for sketching, and besides the interest of partly dismembered boats, or old broken ones, offer the chance of examining boat construction at close quarters. There could not be a happier situation for a boat enthusiast who also likes drawing boats. In a repair yard besides the boats themselves there are generally many kinds of timber, ladders, supports and small cranes. With so much of interest all around it is difficult not to obtain an interesting composition.

For the drawing I chose a side view of a steam trawler having a major refit (105). I drew in pencil, pen and black and white crayons. I also used pale green, blue and grey watercolour washes. I used the crayons because mine was a winter scene and I needed black and white to get a final hard cold effect. The trawler was set upon blocks surrounded by shores and stays. Some of the heavy top planks of the hull were being replaced. The small crane was being used to restore engine parts. Lying round the

boat on the ground were various lengths and shapes of planking for the hull. The drawing took two and a half hours to complete.

The broken boat had been neglected and left for many years and one side was partly covered with soil in which plants were beginning to grow, and old metal drums and other rubbish were heaped around it (106). It had been quite a large boat, perhaps a ship's boat, because there were the remains of three thwarts. Some of the hull planking also remained. I used a *Conté* crayon for this drawing which took two hours. I could have probably gone on with it for a longer time. I found it extremely difficult to define all the light areas; there were so many different thicknesses of wood catching the light. A drawing of this type is really a drawing exercise in which all ones skills are tested. There has to be careful measurement and preliminary drawing to start with, and then there has to be an equally careful building up process which involves the use of light and shade.

Inshore boating and sailing

In good weather inshore waters, estuaries and harbours are busy with small boat activity. Motor boats and motor launches are often prominent for they are fast and so they create noticeable bow waves and wakes. In three sketch book sheets I have tried to capture some of their character (107 and 108). The sketches, which had to be quick impressions, were drawn in pen and ink or slim felt pen, and became primarily a matter of drawing bow waves. Bow waves vary, some rise up as silky moving curves against the slower and larger boats, whereas with sharper stemmed faster boats the bow wave creams up with a large initial wave which breaks up down the boat's side in froth. Lighter and faster boats seem to leap out of the water as they ride forward, their bow waves being pushed rapidly away to their sides. Blunt stemmed boats, if they are heavy, push a wave of water in front of them which is constantly broken into spray and froth; if they are light they ride forward, stern down, sitting in a trough of water. The form and shape of a bow wave needs to be defined against the boats side in the form of a light or dark silhouette. The wave against the boats side is called the transverse system, and the gap between the wave tops down the side of the boat will increase as its speed increases. The other part of the bow wave is the diagonal system which moves out at an angle to the boats progress; there is also a

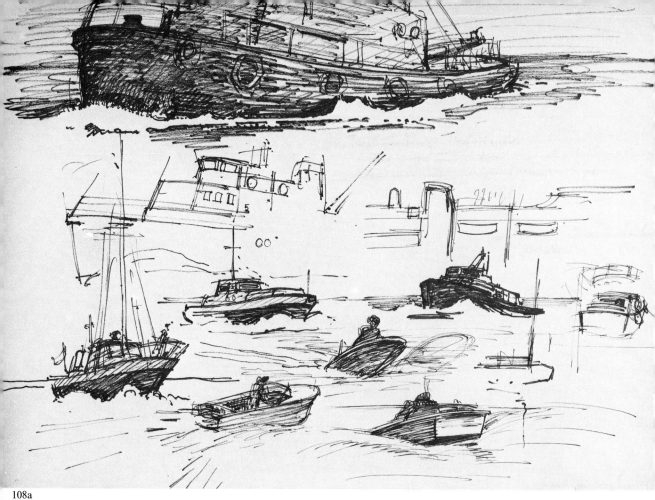

108a

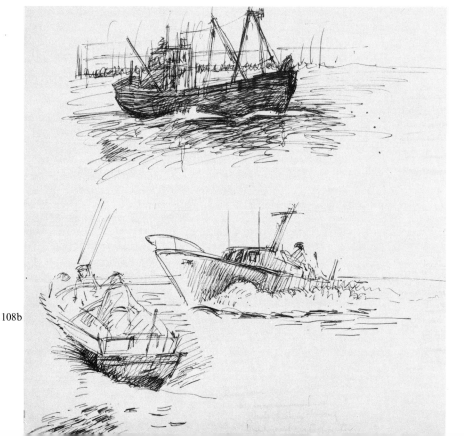

108b

109 J M W Turner
(1775–1851), *Two Sailing
Boats near Shore*, 1797.
Watercolour and bodycolour
on coarse grey paper
(195 mm × 274 mm)
Courtesy of the Trustees of
the British Museum, London

minor one at the stem. These last must be made to merge into the water surface in a drawing. With all the water pushed up and out by a boat going forward, a wake of disturbed water is left which spreads out behind the boat until it is absorbed by the sea, or creates a wash wave over a beach or against a bank. Long lines will generally convey a wake. In general the slimmer the vessel, the less bow wave, and the less troubled the water by its passage. There are more bow waves illustrated in the chapter on ships.

TURNER'S drawing of sailing boats near the shore was made in 1797. It is a sketch book drawing made from an incident he saw at the south coast (109). This sketch book was filled towards the end of a three-year period during which Turner had been employed copying watercolours. The works he copied were those of his English predecessors, particularly Cozens; and it was in this period he deepened his knowledge of watercolour drawing technique and of the imaginative power that could

be employed to express the wonders of nature and its dramatic effects. He had exhibited watercolours since 1790 and this period might be counted as the 'end of the beginning' in the development of his technique.

This is a straightforward attempt to represent everything in a sea piece a well as he could. All the different parts of the drawing are well observed and earnestly drawn and modelled. For also at this time Turner was developing his awareness of the sea and the realisation of its possibilities for use as pictorial subject matter. Another important aspect of this drawing is that there is a recognition that space will always be a fundamental element in his sea pieces, and one which he will never ignore. In the foreground of the drawing, the breaking waves and the two sailing boats are rendered with a tight technique, and nothing is left to chance. He used body colour over his first watercolour washes to secure the solid feeling he wanted from the waves and boats, and also to make the light parts on the

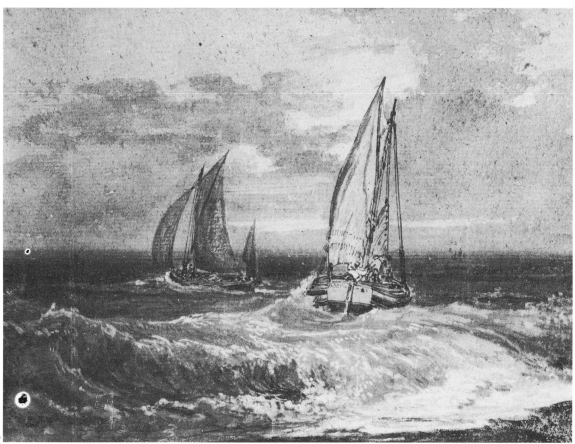

109

111

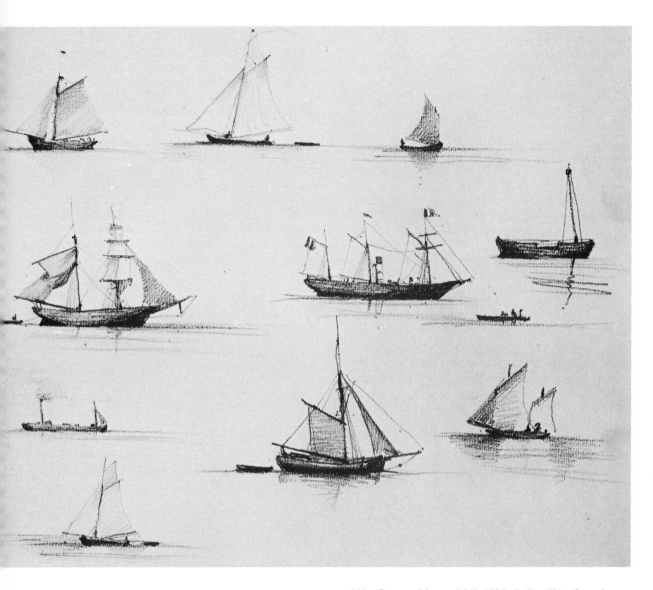

110 CLAUDE MONET (1840–1926), *Sailing Ships* (from the sketch-book 1857). Pencil, each sheet (210 mm × 288 mm) Courtesy of the Musée Marmottan, Paris. Collection of Michael Monet, Giverny Foundation Wildenstein

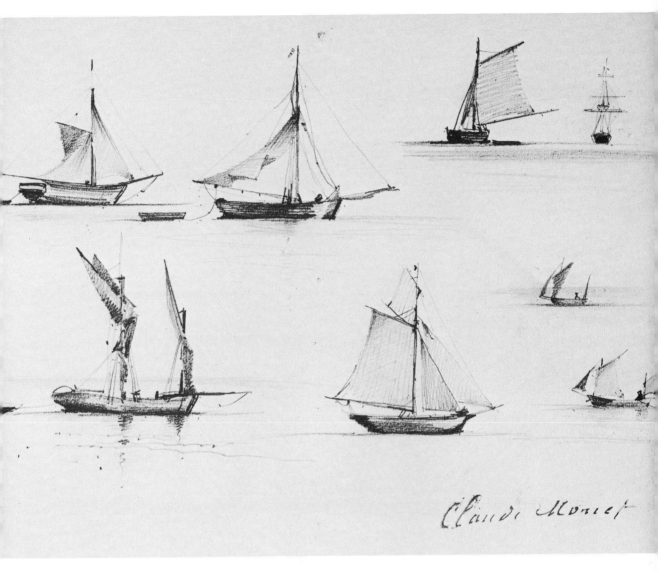

Claude Monet

nearest boat and the froth from the wave caps stand out. It was of course this more solid type of drawing that he did at the outset which allowed him so much more technical freedom later. (See *Blyghe Sand* – 111). Notice the exactness of his representation of the rigging of the nearest boat, and also the elaborate modelling of the wave breaking onto the shore on the left. In both these instances Turner was keen to get the facts of construction correct, and store up drawing experiences of these forms for use in the future. The result is that the drawing does not quite hold together, or is perhaps a little stiff. Stages like this cannot be avoided however if one's drawing, and powers of expression, are to progress.

Sail boats and yachts are a common and beautiful sight on a sunny day on inshore waters or rivers. A sailing boat is a beautiful object and has always appealed to artists. Monet has left us some delightful sea pieces with sailing boats, and made many notes in his sketch-books of different types of craft, sails, spars and rigging (110). His impressions of sailing craft are always faithful to type and thus to the beauty of an individual form. In these sheets of sketches a lugger can be distinguished from a sloop, and a brigantine from a barquentine, but there is no tedious overstatement of detail.

Again I find I am placing Monet and Turner together. In TURNER's drawing *Blyghe Sand* (111)

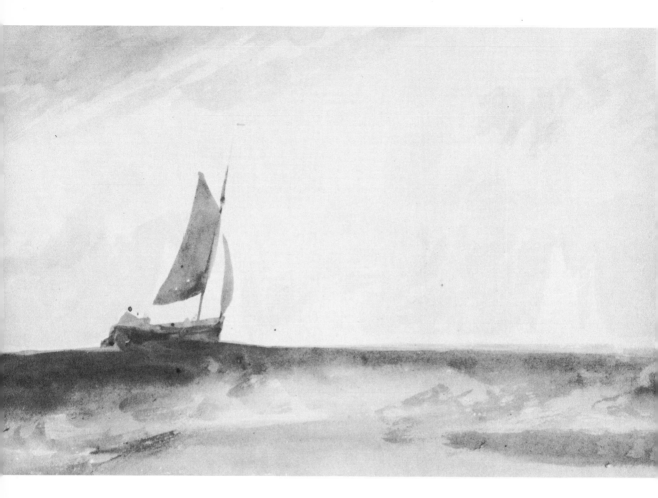

111 J M W TURNER (1775–1851), *Blyghe Sand*, 1809. Sepia wash (232 mm × 349 mm)
Courtesy of the Trustees of the British Museum, London

we are looking at a single boat sailing off shore, and certainly there is no overstatement of detail here. It is drawn with a brush using sepia wash so the drawing looks somewhat warmer than his *Harlech Castle* drawing, the sepia admirably suggesting the colour of the sand. This drawing is a preliminary study for the painting of the same title in the Tate Gallery. The drawing represents what Turner considered were the main features of his composition: the boat's sails and the men in it. Note the deft spot for one of the men's heads; cloud moving diagonally across the top left hand corner of the picture; the suggestion of sailing boats in the distance, particularly to the right, which stand out of a patch of sea illuminated by sunlight; and finally a long dark crest in the sea running across the middle distance and supporting the sailing boat with lighter wave crests in the foreground running into the beach. This sailing boat must have so appealed to Turner that he became determined to make it into a pictorial

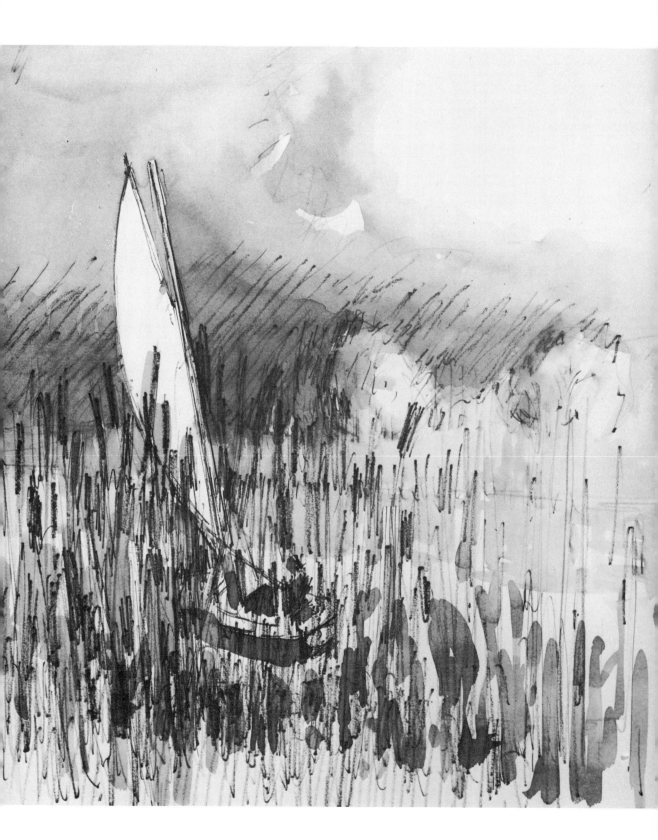

115

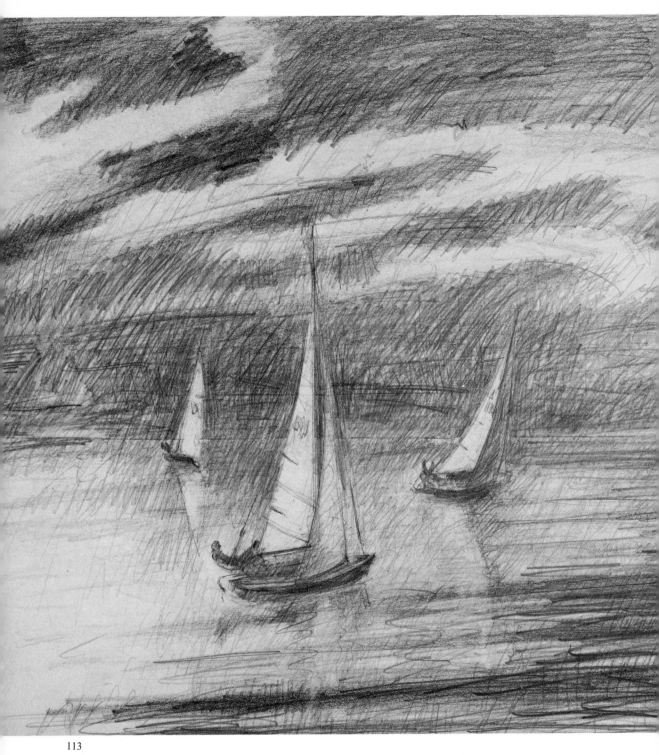

113

114 *The Race*. pencil, pen and ink, white gouache
(525 mm × 755 mm)

statement, and seen through his eyes it is a beautiful object. It could be worth while making copies of this drawing with brush and a monochrome just to try and catch the spirit of the shapes with which Turner represents its sails and hull. Try and hear the murmur of the sea and imagine you feel a sea breeze as you do it.

Sail shapes alone may sometimes provide the main subject for a drawing. In the Fenlands, or other flat country, sails can be seen apparently moving through grass and foliage. A few more steps taken forward will reveal there is a river with a boat moving along it (112). In my drawing there are tall reeds with a small sailing boat passing behind. The first I saw of the boat was the upper part of its rather dirty white sail progressing along. A rapid sketch in pencil established the boat and the size of the sail. The clouds, trees and grasses were all indicated in ink, the drawing being completed with a black felt pen and inky or watery washes.

Sailing is a widespread hobby, and on Saturdays and Sundays there are many small boat races in which any boat owner can join after a few preliminaries. The drawing shows just such a contest held in the early evening (113). This drawing was made entirely in pencil on cream paper. I used HB, 2B, 3B and 6B pencils. I made a brief sketch of the scene and built up the drawing later. What first interested me was the light silhouette of the boats sails against the darkening evening sky, but later I observed the oblique movement of the cloud banks and noticed they parallelled the wave movements on the water. I determined the type of small boat involved in this race in my initial sketches.

Sail boats racing are fine pictorial material. Such work does, however, depend on preliminary sketch-book work and investigation. The example I have chosen from my own work shows what I mean (114). Before I could attempt the final drawing I had

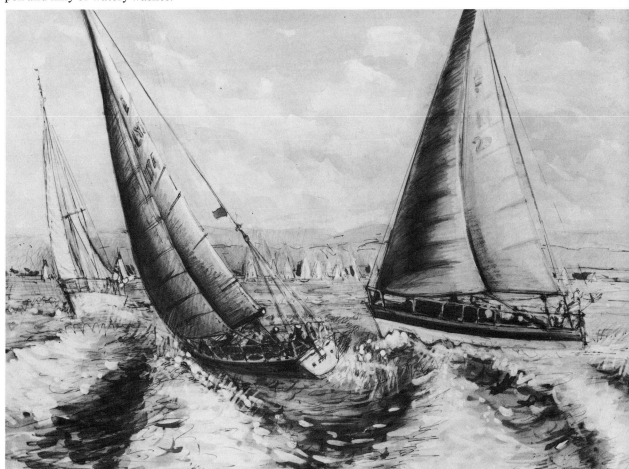

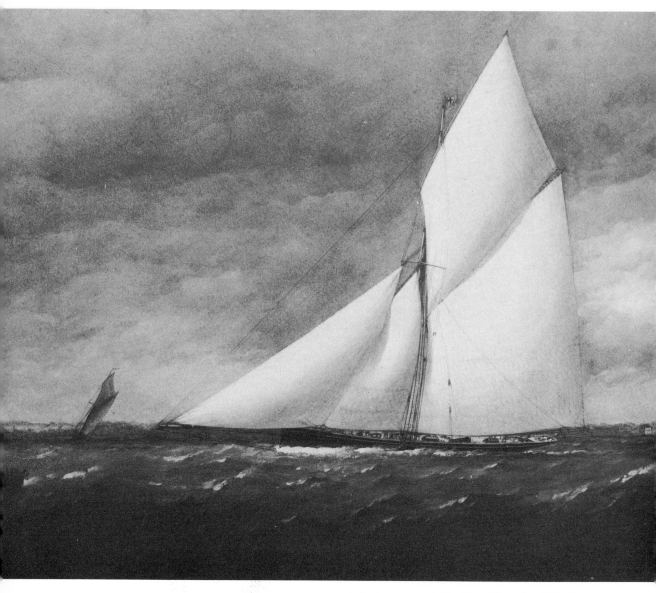

115 Anonymous Artist, *Cowes Town Cup*, 1872. *The Yachts Kriemilda and Arrow*. Pencil, watercolour with body colour over and gum arabic on yacht hulls (403 mm × 732 mm)
Courtesy of the Trustees of the British Museum, London

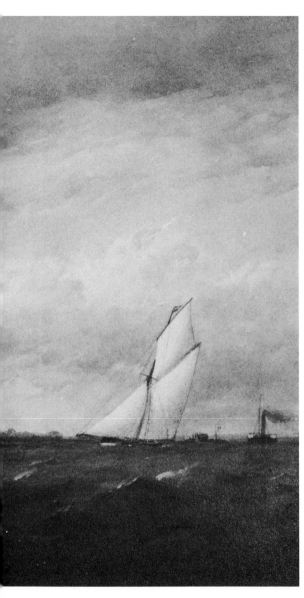

waves by the wind, but in the open sea it is to a regular pattern, whereas the boats heel at different angles as they turn or tack to take advantage of the wind. This drawing was started in 2B pencil and was then drawn in ink. All the tones are of black ink diluted by water. Lights were finally added with white ink. Although the drawing took a considerable time – four hours – I tried to keep my technique as free and as full of movement as possible to match the breezy scene.

I'm sure that everyone who uses this book will love to see these two Victorian yachts at Cowes (115). Unfortunately I was not able to discover the artist's name. A modern racing yacht would provide just as fine pictorial material as this. This drawing was made very carefully with pencil so that the rigging and proportions of the boats were correct, and made two good portraits. However, the movements of the yachts heeling over and answering to a stiff breeze is not lost; nor are the oblique movements of the clouds and waves. The whole drawing is so breezy, and yachts, sun and sky so accurately depicted and felt that one could be almost certain that the unknown artist was a sailor. The final state of the drawing was arrived at by being built up by a succession of watercolour tints. In this drawing notice particularly the modelling of the sails, and all the interest given to the coastline in the distance, and the amount of work and attention that has been given to the cloud base and to the waves.

WINSLOW HOMER is an artist who gives life and movement to every sea piece he creates. *The Sloop, Bermuda,* is I believe, one of his finest pieces. See colour plate 4. He makes the drawing of boats, clouds and sea effect look very easy. Each tone and mark is placed apparently without doubt, and is so direct that the whole picture looks as fresh as if it had just been created. Its assurance and simplicity seem to provide the perfect model to follow. The drama of the dark cloud rising over the horizon and the movement of the sea is such a close likeness to nature and an unforgettable image. In the drawing of the boat, Homer shows exceptional ability for feeling and rendering form and light. What also should be recognised is that the picture is built up with three contrasting parts: the boat and sail, the sky and sea, and held together by the use of related marks and directions. The oblique direction in the clouds is repeated and balanced by the curious intertwining of the partly furled sails; and the undulations in the sea are repeated again in the shapes of the boats and across the clouds.

to be sure I understood the proportions and rigging of the type of cruiser/racer boat I had seen. I wanted to try a three-quater stern view of my nearest boat, and to do this I did need a certain amount of information on the boat's cockpit, rigging and cordage. Height and breadth of sail to the length of the boat was also important. In carrying out a work like this it has to be realised that the water is only incidental, the wind is the most important factor, and a feeling for it makes the picture. The boats heel over and are pushed by the wind, and are sailed in response to it. The water, of course, is pushed into

Ships

The forms of ships are designed by the most unselfconscious sculptors, for the marine architects who create them are much more concerned with the capability for cargo carrying to maximum efficiency than with aesthetics. Present methods of ship production do not help; construction is now largely carried out with flat steel plates, so there are fewer cambers and curves in a modern ship. Yet the total form produced, odd sometimes though it may be, even mis-shapened, will very often arouse our admiration and we shall see it as a beautiful object. For instance, nothing is more beautiful than the shape and lines of a freshly painted ship seen in bright sunlight dipping in a swell or driving through the water. The working nature and uncompromising engineering of a ship is revealed when, with rusting and age, it begins to show the individual steel plates from which it is made, and wear shows on the derricks, masts, stanchions and other parts of the superstructure. Ships too are highly individual, even two sister ships are never completely alike because some slight alterations or improvements will always be made to the second launch of the same type. Ships do many kinds of work and their shapes and fittings are adapted to suit their individual requirements. Some may carry people and cars, others cranes or containers, or foodstuffs, chemicals or fuel; the list is almost endless. Today there is more variety than ever in the basic ship form, and any mechanical or physical apparatus it would be possible to imagine can be seen sooner or later on a sea-going vessel. Ship types are becoming more and more indefinable, each one being invented to fulfil a particular need as it arises in industry and commerce.

Sketching ships

Much the same approach wants to be used for drawing ships as that I described for drawing boats in the previous chapter. That is, the initial feeling wants to be for a tub-like form expressed by lines: lines which both run the length of the hull and go round it (116). This sketch-book sheet of three ship studies shows what I mean. This sort of study can be made from ships in port or from photographs of ships. These three sketches are in pen and ink. Again I would say let your lines be as free as possible. Do not be afraid of overdoing the tub-like quality. None of the three ships I have sketched are heavily laden with cargo so they ride high in the water. Lightly-laden ships have an advantage when you are learning to draw them, because you can see so much more of their hull shapes. By looking at the stem and stern shapes in silhouette, try and determine the cross-sectional shape of the ship you are looking at. Look at the drawing of the ship on the right hand side of the paper and see how I have done this. The sectional lines coming down the side of the ship balance against the silhouette of the stem shape. Look at the sectional lines around the other two ships and you will see that they appear to pass underneath; and that is what I felt they were doing. Just let yourself be free. These are practice drawings to allow you to feel the form of ships, so let the lines go right under. A further sketch-book page gives an extended variety of ships shapes (117), also drawn in pen and ink.

The third sheet was drawn with a fine tipped felt pen and not so many construction lines were used. Make these rather more direct drawings after having made the drawings with plenty of constructional lines (118).

Tubs

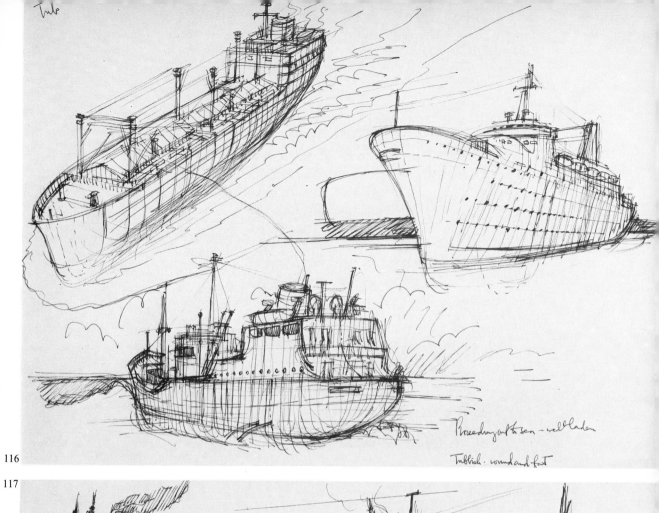

Proceeding out to sea - well laden

Tubbish - round and fat

116

117

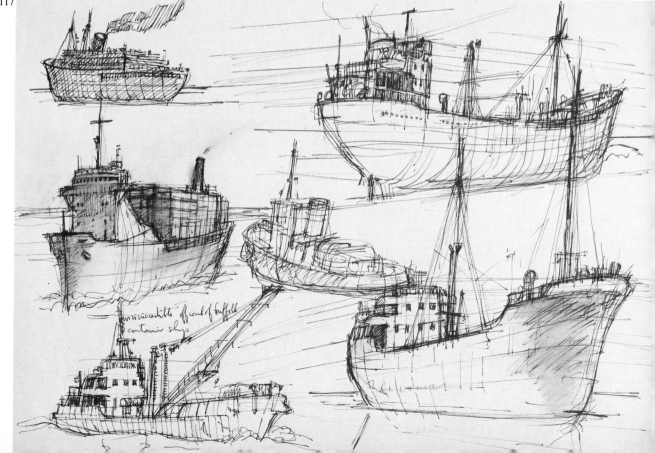

an incredible offered of Suffolk
container ship

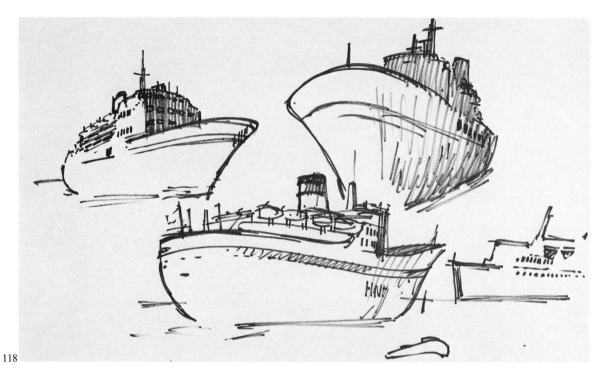

118

119

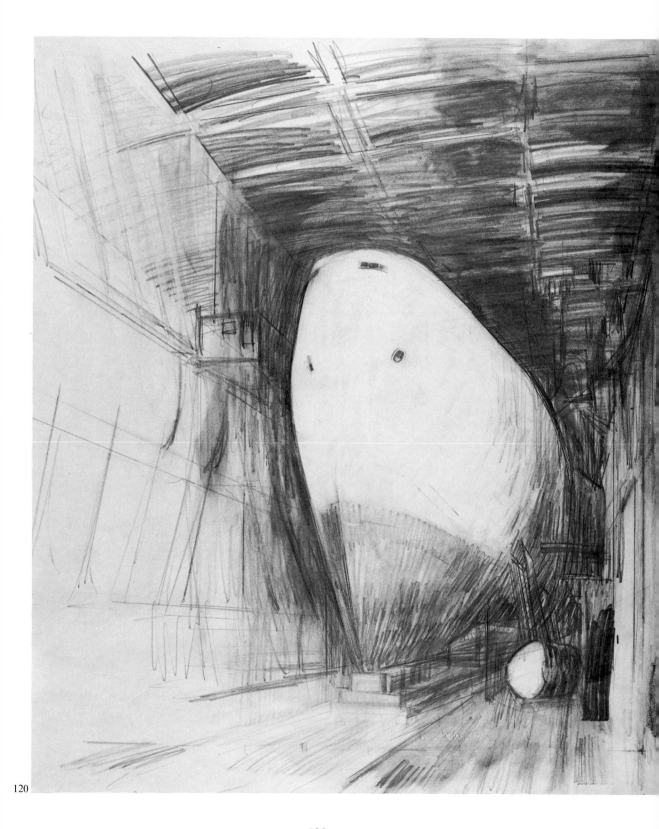

Ships differ from boats because they are much larger; they are vessels for holding cargo and passengers and have a variety of superstructures which enclose them in layers above the waterline. They can be extremely high and large, and when one is near them can be as awe-inspiring as a cathedral. Because they are so large, most of the bulk will appear above the horizon in a near, or not too distant view. Look at the ship in the bottom right hand corner of 117. This is a small cargo vessel in ballast, and most of the ship is above the horizon. I have left the perspective constructional lines that I used to establish the vanishing form of the ship from stem to stern. You can see by the direction of these lines that they are vanishing left and right from the ship down to the horizon. This drawing situation is called above eye-level perspective. The stern view of the ship drawn above is in exactly the same perspective situation.

The views of ships drawn in felt pen (118) were also seen mostly above the horizon in above eye-level perspective.

I often make large drawings of ships hulls so that I can be more fluent at drawing them in a variety of positions and expressing my feelings about their enormous bulk (119). I made this study with a *Black Prince* pencil and also used a small amount of watercolour wash. I aimed for an image that would express the size and might of the ship that had slid past me and steamed away. As I was drawing I felt the power and weight of the vessel and tried to imagine the handling of its huge bulk. I decided on a very simple treatment with heavy lines to convey what was in essence a large, rather squat sculptural shape. I only used the line markings to feel the form of the ship. I did not blacken it in completely because I also wanted some effect of lightness, for the heaviest metal hull floats suspended in water.

Any ship in dry dock is impressive, particularly from stem to stern view (120), because then its lines are exaggerated by the effect of above eye-level perspective. There is really no better visual experience than this for stimulating a draughtsman's sense of form and imagination. The immense bulk of the hull is held upright by metal stays and supports, and the sectional shape of it made clear by its plating and the supports fastened against it. I made this drawing with 4B, 6B and *Black Prince* pencils. I kept the stem of the ship white as a contrast to the gloom of the interior of repair shed and the roof. This ensured that it appeared to come forward and that all the rest of the hull was

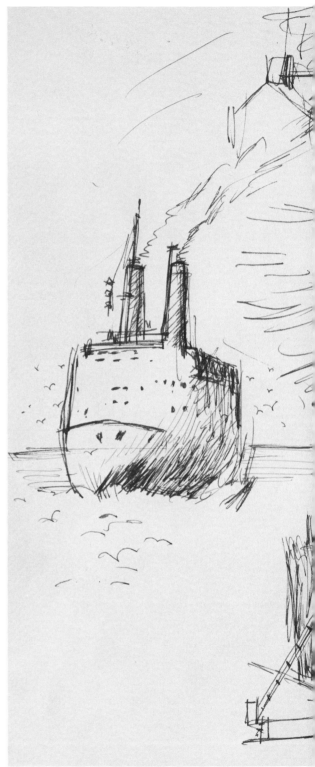

121

124

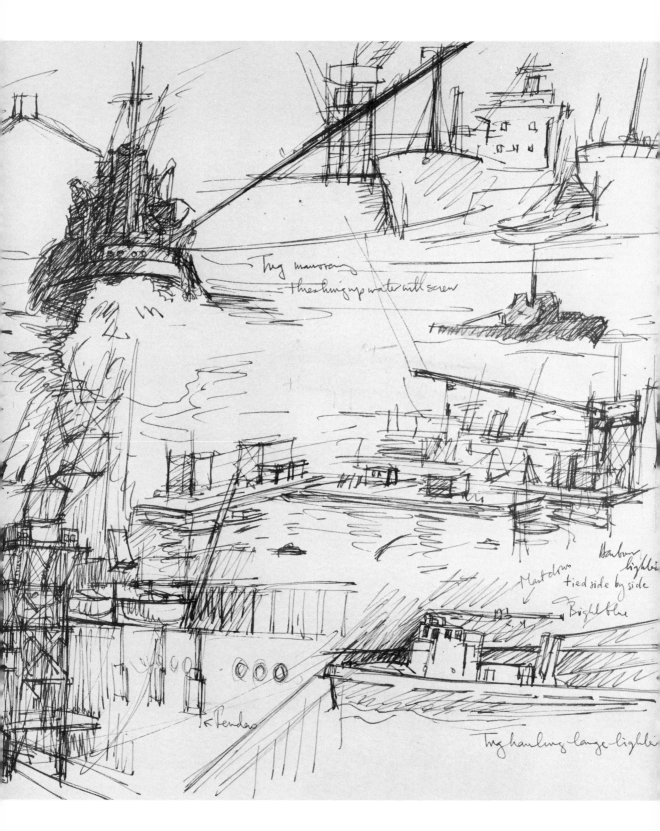

Tug manœuvring
thrashing up water with screw

Harbour lighter
Mast down, tied side by side
Bright blue

← Fenders

Tug hauling large lighter

125

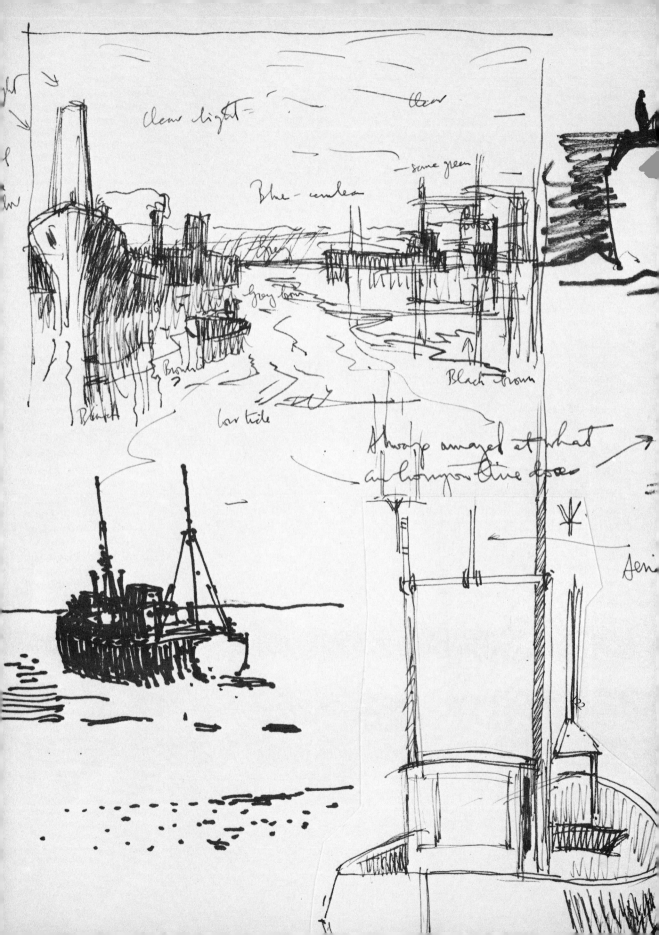

Clear light ≡ ≡ ≡ Clear

some green

Blue — cerulea

Grey tone

some green

Black tone

Brown

Black

low tide

Always amazed at what an horizon line does

Seri

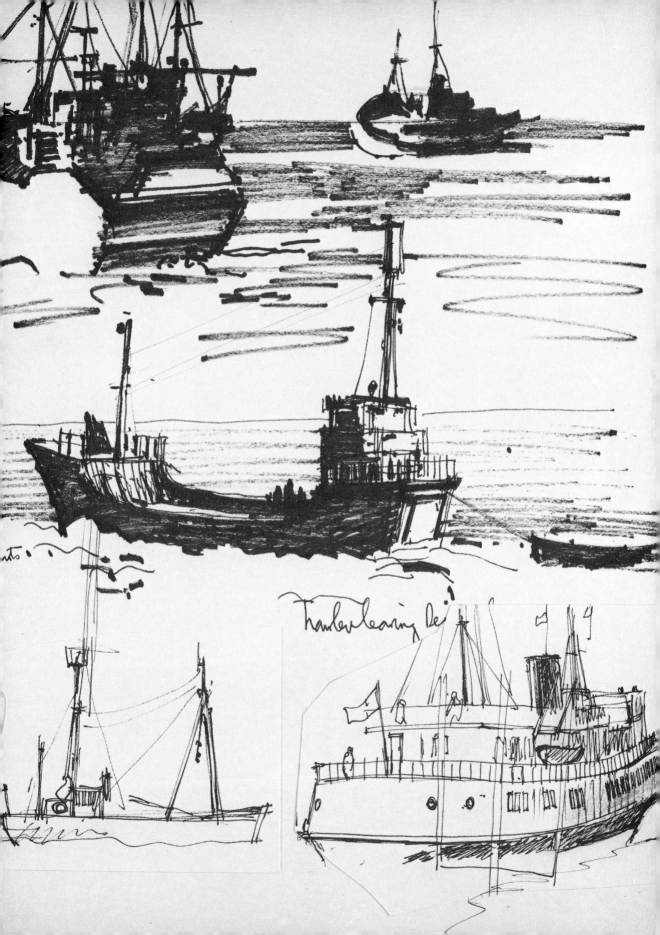

Trawler leaving Dock

vanishing back into the shed. I used a putty rubber to clean out light areas where necessary. Although such a subject is very simple I would recommend it because it does provide such good basic drawing practice. Perspective skills will be improved and a good deal of modelling is required, of which we can never practise enough. Obviously, also, it is a good way to learn about ship form and construction.

Sketch-book studies

Given the initial interest, regular sketching should rapidly improve knowledge about ship proportions and shapes, and the more important variations in superstructures and rigging. Every opportunity should be taken for sketching ships. Even slight sketches, or half finished ones, will help.

Not all ships are stationary in port, and even if they are you may find that other ships or boats will come up and pass between you and the ship you are drawing. So you must be prepared to leave one sketch and start another. I would advise that on certain occasions you just spend your time making jottings of details or many small studies on one sheet (121 and 122). These two sketch-book sheets of mine show the sort of thing I mean. The first sheet was drawn with a pen, the second with pen and a fine felt-tipped pen (121). On the first sheet there is a study of an ocean going car ferry leaving harbour (notice how I have created the feeling for the hull bulk with many pen lines round its shape). Also there are two studies of tugs, some lighters and part of a large ship alongside a dockyard crane. All the sketches were made very quickly, although I did spend longer on the rear view of the tug at centre top, because I wanted to get the effect of the wash it made as it increased power and raised the spray at the stern. The second sheet contains studies of fishing boats, a pleasure steamer and, in the top left hand corner there is a compositional study I made of a whole harbour scene (122).

When you are not making general jottings, I would suggest to you that you have a theme in mind that directs your sketch-book work towards a certain goal. The next sketch-book studies show themes that I have pursued myself (123). The first theme is silhouettes. With these drawings I devoted myself to the task of getting main proportions correct. Ship's length in relation to hull height, superstructure length in relation to ship's length; number, type and height of masts; angles of masts and funnels; bow and stern angle and funnel shape.

These are the kind of visual data I aimed to record. The drawings were made in pen and ink and then filled in with a brush, because I wanted to see my silhouettes as flat shapes so that I could recognise their general features at a glance.

My second theme is ships superstructures (124). The remarkable appearance of many present day ships is created by the height of their superstructures above sea level, particularly the bridge area. This height is necessary on a long or large vessel, so that navigating officers can have a clear view when manoeuvring it in port or at sea. The first sight of such a high structure standing out of the flat plane of the sea can be quite a visual shock, and to see a long super tanker or container ship with high bridge structure proceeding down channel out to sea can be a most stirring sight.

In the first sheet of drawings (124a) there is a study of an ocean going ferry. This type of ship is quite a giant. It has an appearance that is rapidly becoming familiar to us. The superstructure which is in a number of tiers, occupies more than three quarters of the length of the vessel, and this is done to increase the deck space. The same kind of superstructure is now being used for cruise liners. A ship of this type is not obviously exciting to draw. At first sight it is just a large square shape. Like all ships it does however have some rake to its lines. The inclination of the mast and the leading edges of the superstructure and the funnel are at the same angle. The stern shape inclines towards the funnel, which has a rear surface at the same angle; and the superstructure edge forward of the lifeboats also inclines forwards in the same direction. So there are two opposing and rakish movements balancing each other in the ship's design which give it style. I sketched the mast and funnel twice so that I could understand them better. The other drawing on the sheet was of a variation in superstructure construction which caught my interest. Here the ships bridge, and an accommodation unit below, have been built round and into the funnel. This combination is occurring more and more, and this example I felt was worth studying and noting.

The second sheet of studies is largely devoted to the superstructures of container ships (124b) and is drawn with a felt pen. They are quick sketches made to study the appearance of the accommodation unit with bridge on top standing high above sea level. Also amongst the sketches are pen drawings in line where I attempted to search for the balance of movement between the long rakish lines of the hull

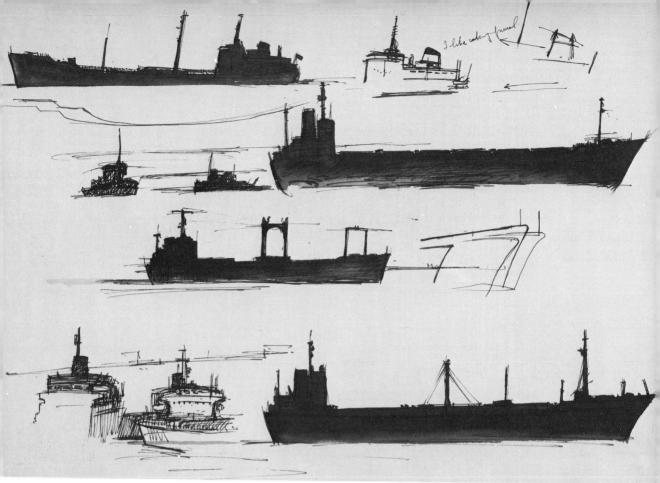

123

124a

129

124b

and the rising block of superstructure at the stern in this type of ship. In this sort of line sketch one is searching for the sculptural design of a ship. Also on this sheet there are two quick sketches in pen and ink and wash of two passing ships. The top one is a cargo vessel with attendant tug standing by. It has a more conventional central accommodation and bridge unit. At the bottom is a profile of a fishing vessel showing rigging of wireless aerials and derricks.

The third theme is the study of bow waves (125). The two sketches with long hull shapes were made so that I could record the bow waves made by a large ship in calm water. I used felt pen and left the bow wave white between a dark ship and the water. In a calm sea the bow wave and wake gradually spread out, expand and appear as light froth.

At the stem the bow wave creams away from the prow of the ship and undulates along its side, at about midships it begins to break up. The disturbed water alongside a ship forms a definite curved pattern as it spreads away from its side. In the other study of the container ship with superstructure, the bow wave is greater and the sea more disturbed. This ship was moving faster in a strong swell. Below is a drawing of a barge being towed, in this case the bow wave is a mound of water being continually pushed up in front of a rather blunt stem. Two other pen sketches (opposite) show smaller bow waves. One is the effect of the bows of a light fishing vessel moving quite fast in choppy water. The light form of ship rose and dropped as it progressed and the bow wave splashed up. The other is of a light ship in a river mouth. There was a slight swell and the ship was moving slowly, so the bow-wave only created a slight lapping effect.

Ships and docks

Drawing ships that are docked or alongside wharves will probably mean drawing much else besides. It is extremely difficult to draw a ship in

130

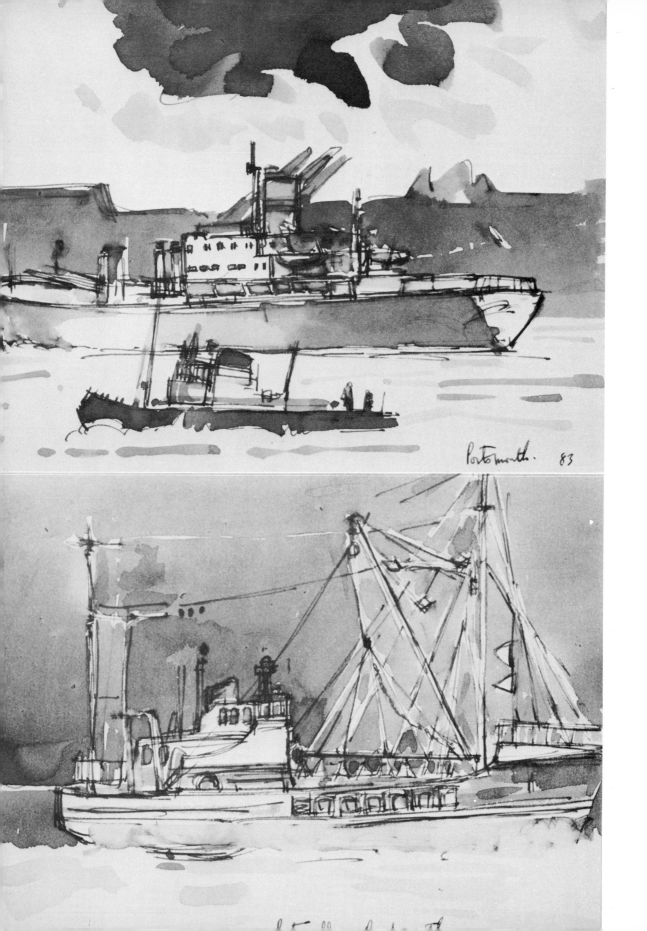

Portsmouth. 83

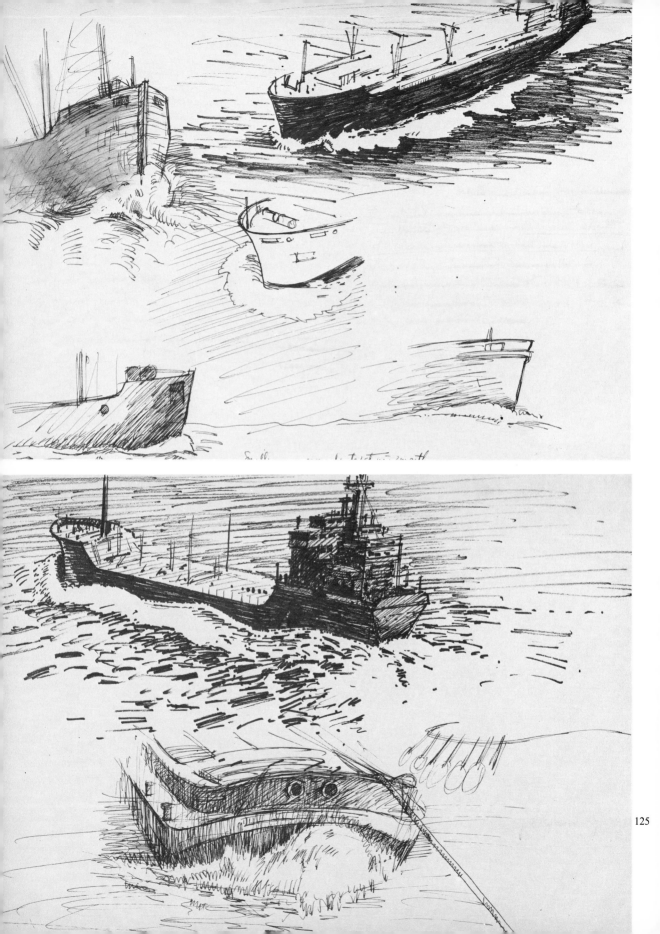

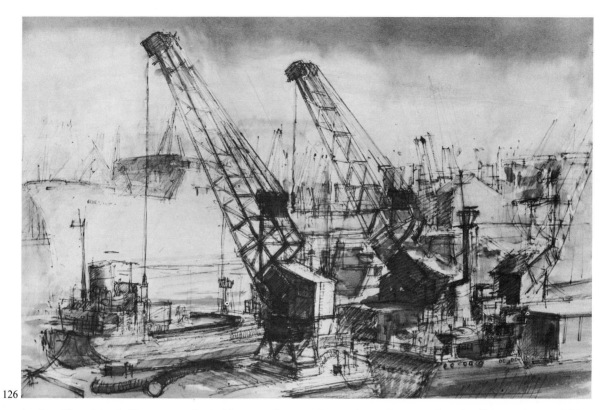

126

dock without including some dockside paraphernalia or equipment. Different industries and branches of commerce served by shipping have their own specialist wharves and piers. Each one will have its own type of crane or unloading gear. For those interested in mechanical things and who do not mind drawing a great deal of detail, dockland can be endlessly absorbing. *Cranes and ships in dock* (126) is a study in which I made two cranes the centre of interest of a composition. This drawing was started in pencil and then after half an hour or so I used pen and ink, and washes of grey watercolour and ink. The drawing took about three hours to complete. A great amount of time was spent on drawing the cranes. In the beginning I made sure that the perspective of them was correct. I drew two working together so I could work from one to the other to get the perspective directions correct. The drawing gradually spread to the ships each side of the cranes with touches added now and then to all the cranes making the background and also the cruise liner across the dock. The distance I left as an impression. Had I given it more detail I would have muddled the appearance of the cranes. In a painting the cranes would have to be made sharper and

clearer throughout so that the distant view could be more defined. However, a drawing is a picture in lines or marks and should be kept so, it has then a freshness which is characteristic of it, which a painting might not have. A free drawing can also suggest much more than it depicts. What I wanted to suggest with my crane drawing was how busy the docks were, but also how harsh they were and removed by necessity from the open sea and natural things. I did wonder whether I should do more to the drawing but I eventually decided it best to leave it thinking that more finish might make it look too heavy.

I chose HENRY RUSHBURY's *Ship in Dock* (127) because very straightforwardly it is what the artist says it is. Ships of this type are now of course out of service but I do not think this makes the drawing any less pertinent for us. The drawing is in pencil and watercolour and is a portrait of a working ship. Although docked, the ship is being loaded from lighters alongside, and a tug waits to take the lighters away. In the foreground there are barges and a boat. In the background warehouses and houses. The ship is exactly in the centre of the composition, its tall funnel almost making the

133

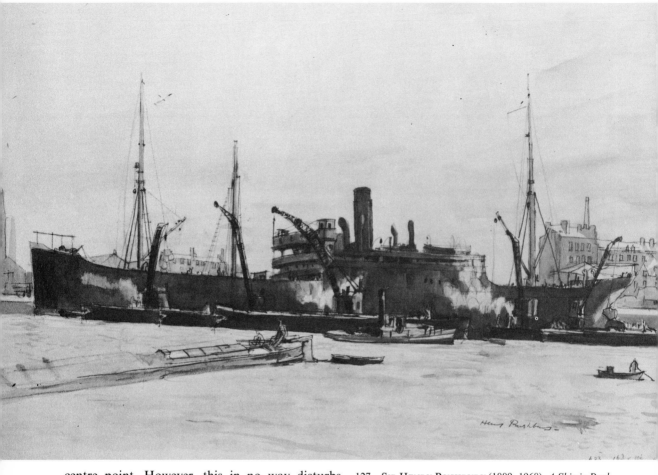

127 SIR HENRY RUSHBURY (1889–1968). *A Ship in Dock*.
Black crayon and watercolour (295 mm × 440 mm)
By courtesy of the Trustees of the Tate Gallery, London

centre point. However, this in no way disturbs because every other feature in sight, masts, cranes and buildings, is irregularly spaced out and creates a tantalising interest of its own. The ships stern mast, the warehouse block and the two lighter cranes create interest which pulls the eye from the centre of the drawings towards the right. The ship has two foremasts which create irregular interest to the left and the two lighter cranes on the left of the ship's funnel lead the eye away from the centre. Altogether, although seemingly so unobtrusive, this drawing is full of teasing visual moments which sustain one's interest.

CHARLES PEARS'S *Transport loading at Night* (128) shows a ship drawn in above eye level perspective. Its bow rears up into the front of the picture, and like the ship in dry dock makes an impressive image; but here we have as well the counter attraction of searchlight beams probing the night sky. All this, plus other dockyard detail, Pears

manages to knit into a rich tonal pattern and gains a striking pictorial effect as a result. A focal point is achieved amongst all the tone changing by keeping the light on the ship unloading brighter than all the other lights in the picture. This central light contrasts well with the ships velvety black bow. This exciting picture could I believe inspire many to attempt drawing close-ups of ships. The method of cross hatching lines to achieve different strengths of tone is certainly one reason why it should be used for study.

In SIR MUIRHEAD BONE'S *Ready for Sea* (129) we meet an artist who loves mechanical imagery and who has a keen eye for detail; but detail for reasons of animation and correct atmosphere, detail

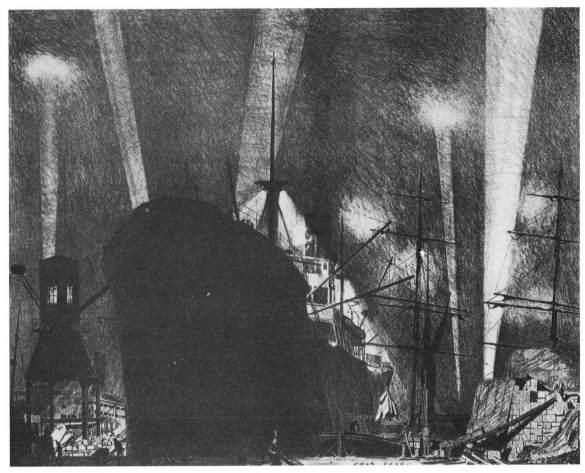

128　CHARLES PEARS (1873–1958), *Transport Loading at Night*. Lithographic print (365 mm × 465 mm)
Courtesy of the Trustees of the British Museum, London

handled with breadth, not *finically*. There is no fussiness, all the parts of the drawing are in correct scale and the main compositional lines which hold the drawing together are architectural in conception. On the left the lines of a huge gantry rear up, making an inner frame for the drawing and cutting off nearly a quarter of its surface; these lines interestingly are slightly oblique and make a magnificent stroke which balances the horizon line which is not quite half way up the drawing. These two big directions effectively isolate the sky which is kept absolutely bare to balance against all the activity of detail elsewhere. With such a conception at the outset how can an artist fail?

The powerful drawing of the destroyer and the lines of the dockside all use one vanishing point somewhere near the base of the gantry. Many directions in the destroyer and dockside lead to this one point and so the spectator's eye is kept securely in the drawing. It also serves to simplify or bring together much of the drawing's detail. The remaining unification of detail derives perhaps from the line of the gantry edge, this near perpendicular picks up, or reflects, all the other perpendiculars throughout the drawing and makes sure we have but one overall view of them. Ship's mast, crane hoist end, ships davits, sailors and dockside workers figures are all joined together to make a perpendicular texture. The drawing works down from a very interesting and large division of the paper surface at the outset to a smaller and still smaller marking at the end. One particular knack that this artist has which fascinates me is the 'cutting out' of light areas between the darks. He has a good eye for achieving proportional balance between black and white.

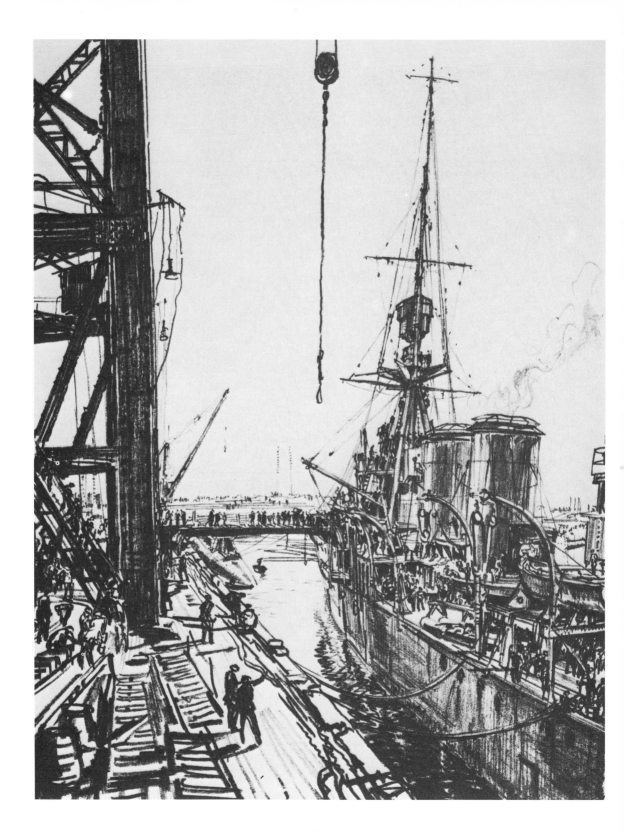

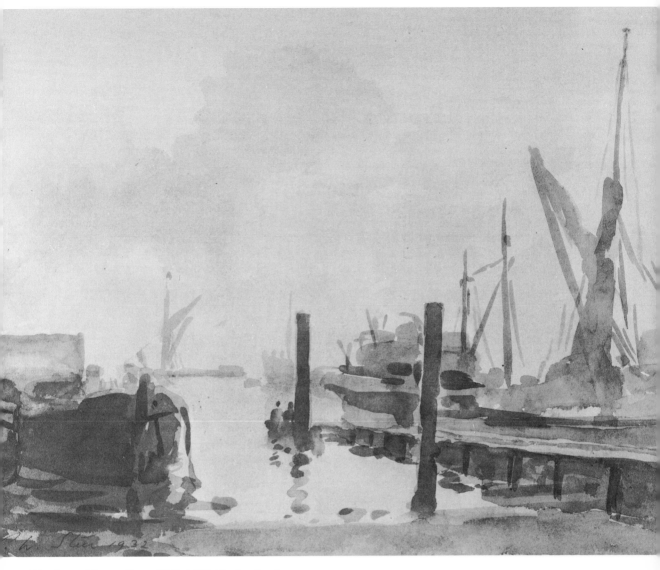

130 PHILIP WILSON STEER (1860–1942), *The Landing Stage,
Greenhithe*, 1932. Watercolour (240 mm × 313 mm)
By courtesy of the Trustees of the Tate Gallery, London

129 SIR MUIRHEAD BONE (1876–1953), *Ready for Sea*.
Lithographic print (356 mm × 465 mm)
Courtesy of the Trustees of the British Museum, London

STEER'S watercolour drawing of a landing stage is executed in quite a different style (130). It is in watercolour without pencil line and is very broad in treatment. It sets out to capture atmosphere and mood more than detail. No edges are delineated and there is a suggestion of mist, or a grey winter day. The centre of interest is two mooring posts and their reflections which leads the eye into the picture, two figures at the bottom of the furthest post lead the eye further in and across the water to the mast of the sailing barge. A block of interest is made by the moored boat on the left, on the right much interest is made from more barge masts, yards and sails, and there is a largish vessel at the end of the landing stage. This must be the approach that many would like to try, being so imple and direct. I would say go ahead. To start with use tones of one colour, and try and work from a subject that has plenty of interest. Posts, masts, yards, sails and ships. Limit your tone layers to between four to six in number. If the work gets messy leave it to dry and work on it another day. It does not matter if you accumulate a few pieces of incomplete work; I find that it is quite useful on occasions to take up work again that has

been put aside for a while and complete it. Finally if the tone drawing fails you can always do more work over it, once it is dry, in pencil, pen or crayon. You have nothing to lose and everything to gain from these kinds of experience.

A characteristic of a busy modern harbour with docks is that there does not seem to be adequate space for all the different types of shipping and boats to move about in safety. Indeed it often appears there is often barely enough room for a freighter or cruise liner to be manoeuvred against or away from its wharf or pier. I made this large drawing of such a busy type of scene (131). From the point of view of compositional considerations it does not seem to matter too much in which direction you look to find a subject. The possibility of compositions surrounded you. Cargo ships, cruise liners, tugs and lighters are everywhere.

I finally decided on a scheme that included the three quarter stern view of a large motor vessel and a small part of a cruise liner against a pier. In the distance was a row of off-duty tugs with a working tug in the foreground. I made the drawing in pencil, blue watercolour washes and white and grey

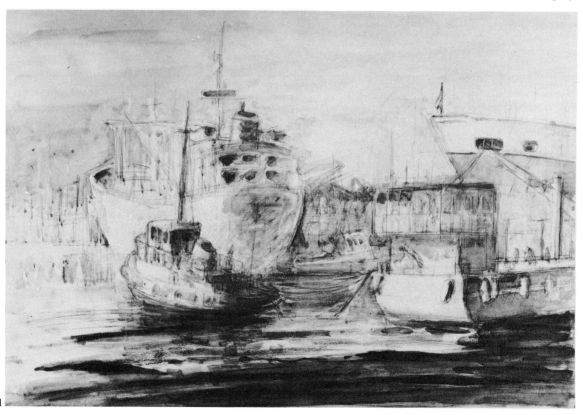

131

138

crayon. I built the drawing up in pencil and pale blue washes in four or five stages and the final marks were made in crayon. This drawing is a compositional sketch and not a completed picture. There is a lot of information in it that I shall use in the future. I think we should start most drawings in an exploratory spirit not knowing, or being able to visualise, a finished effect. It is in the nature of drawing that it should be unpredictable, its final stages containing elements that surprise us. This means that our best work will be fresh and stimulating and perhaps other work will not be quite so successful, but all the life goes out of drawing if you look only for uniformity and keep trying to repeat past success.

Ships sailing

Drawings of single ships entail making the image large or significant enough to fill the format you have chosen. The composition or the ship's relationship to the paper can finally be secured by using elements from the sea and sky around it.

There is no need to try and imitate exactly all a ship's details; a pictorial rendering does not call for this. Detail has to be sacrificed for vitality of presentation and the continuation of a total illusion. The image of the ship must be drawn in such a way that it dominates the format. The size of the drawing must not be allowed to affect the scale of the ship which should always have a quality of largeness that will excite the viewer. My drawing of a large motor vessel (132) shows what I mean. My first aim was to convey the enormous length and size of the vessel and next to that an appreciation of the shape of the hull and superstructure. Moving in the open sea it appeared not ungraceful, although also somewhat ominous, because most of it was painted black. A few crew were visible but I felt they were so minute in relation to the height of the ship from the sea that it would detract from the scale of the ship, and therefore the visual impact, if I tried to represent them; and this of course is one example of why detail should sometimes be omitted.

132 *Large Motor Vessel.* Ink, felt pen, *Conté* crayon and gouache (500 mm × 624 mm)

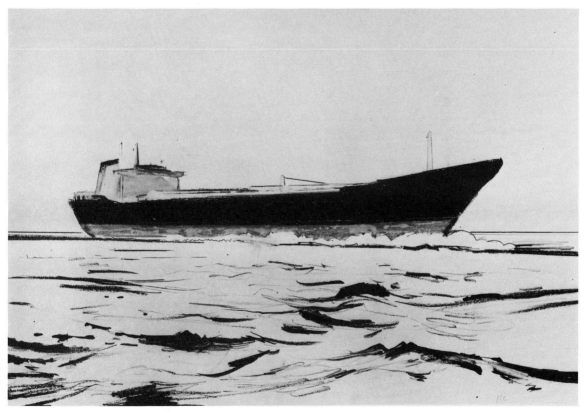

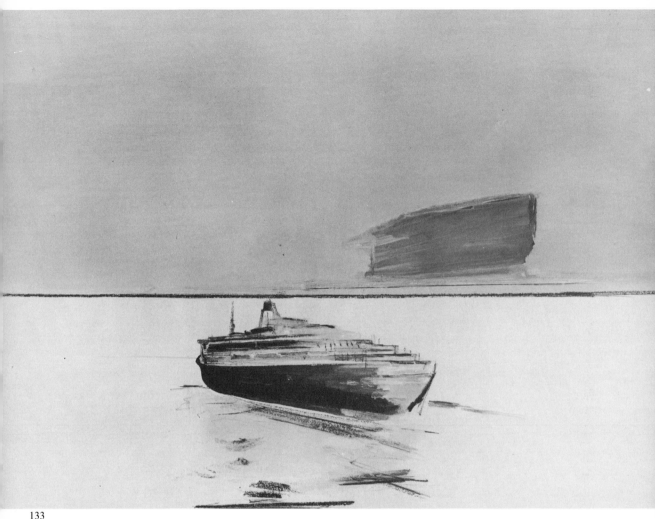

The materials used were *Conté* crayon, black ink, felt pen and gouache. It is a studio drawing as are all my other drawings of ships. I decided to leave the sky bare so that the silhouette of the ship would stand out crisply and starkly and appear very much as a foreground object. For the sea I decided on a treatment that would contrast with ships in texture movement and mood, as the ship was filled in completely with tone, the sea I decided should be broken up. As the ship made one long movement, I put many curved rocking movements into the waves. Finally as the mood suggested by the ship was dark and ominous I tried for some lightness and delicacy in the use of my lines to suggest the sea's swell and waves. So all the way through the drawing I considered all of its parts and their relationship to one another.

In the next example, I took the risk of making the ship small in relation to the paper (133). This treatment of a ship and smudge of cloud in perspective suggested itself to me as I considered the subject of a cruise liner leaving harbour on a clear bright day. I made the drawing with pencil, black crayon and gouache. The sky was made in clear light blue, the cloud added in light brown, having lines converging with the perspective of the ship. I invented the converging perspective lines to convey the idea of the ship moving away into the distance. The dramatic interest they provide compensates for the small scale of the ship. To make sure that the perspective lines of the ship were dominant enough I extended them towards the front of the picture by depicting the whip's wake. I kept the drawing of the ship compact and simple so that it would appear

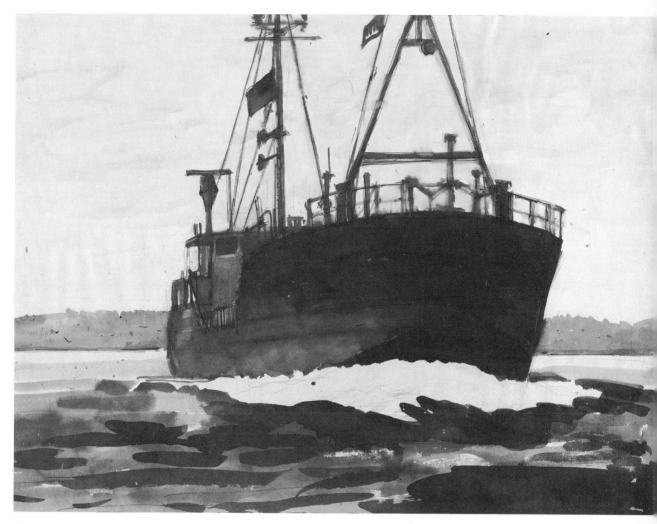

134 *Small Motor Vessel.* Pen and ink (480 mm × 660 mm)

small against the surrounding elements of sea and sky.

This drawing of a small motor vessel was made initially as a study of a bow wave (134). The ship is of a barge-like construction with a broad flat bow and stern. It was travelling down river on a grey dark day and the bow wave appeared as a white roll of water being pushed in front of it. I decided on a drawing that would give focal interest to the bow wave, but allowing the rigging to supply other visual interest. I wanted to create the impression that the ship was bearing down on the spectator. Accordingly I left the area of the bow wave as white paper and made the ship's vow and the surrounding water very dark. This strong contrast of tone brought the bow-wave effect forward and made it very prominent. The remainder of the ship, water and far river bank I kept in lighter tones so that they appeared to recede. I used pen and ink for the line drawing on the ship's superstructure and rigging, and pen and black ink washes for the tones, which were sometimes diluted with water.

Postscript

I hope that there are not too many doubts left about how to begin work.

If, having chosen a subject, your work does not immediately advance as quickly as you would like, do not be deterred. There are so many different types of start, some of which are quick but some are slower. If it should be slow it does not matter, the risk has been taken the paper is no longer empty. It is a strange fact that however accomplished we may become the first drawing marks always seem a risk. Once you have begun, try and make sure that some lines extend to the edges of your paper. Certainly do not become over concerned about small detail, but try to think about the whole effect of a scene as a composition.

If you find that working very lightly at first is beneficial that is good, there will be a future time when you can make more vehement and darker marks. In the first stages of a drawing you work out your own ideas on the paper, and this is a private process. You must not feel you have to produce a stunning effect right from the start. Generally we have to go slowly in the beginning so that we may go more quickly and surely towards completion.

The marks in your first stages will probably become covered by later ones, and so they can be considered as a framework on which the drawing grows.

Even if it were desirable it is not possible to copy nature's effects realistically. Shifting clouds, changes in light and the movement of water, boats and shipping all combine to present animated subject matter, which can only be rendered in a drawing by a process of personal selection or interpretation. We are fortunate in having a lively visual stimulus, but the constant movement with which we are presented is a further reason why we must build up stage by stage, giving ourselves time to discover what we want in the completed drawing.

Avoid compositions which are too crowded with detail or incident, often the choice of one part of a subject is sufficient. The view-finder that is described in choosing a subject in the beginning is an excellent aid towards doing this.

Also be prepared to sacrifice one part of a developing drawing for the good of the whole. This, I know from experience, is not as easy as it sounds, because it is often the part of a drawing that pleased us in the beginning that must go. It was probably the part that got us going in the first place; yet, nevertheless, it may become an impediment in the construction of the final form of the drawing.

Finally, I would say that if you have a strong feeling about how you would like to start then go ahead, for by discovering a workable composition for yourself you gain in assurance and confidence. Although you may seem to be throwing theory to the winds, it may be that by a process of visual memory and recognition, you have used a solution that you became acquainted with, and affected by, in the past. The important fact remains that your imagination was fired by a subject and you were able to develop drawing ideas to convey it.

Index

Numerals in *italic* refer to page numbers on which illustrations occur

Austin, Robert 105; *104*
Anonymous artist, Cowes Town Cup 119; *118*
Atmospheric perspective 71, 77

Barbizon painters 9
Balance 19
Bays 44–45, 48
Beached boats 88–96
Bright, Henry 62; *64*
Brush and wash 12–13
Boat drawing 83–86
Boats 83–119
Bone, Muirhead 134; *136*
Boudin, Eugene-Louis 9
Bow waves 109–111, 130

Castles 48
Chalk 14
Charcoal 14
Cliffs 34, 38–39
Cloud studies 76–82
Clouds as form 73
Coastal features 48–54
Colour usage 15–16
Composition 20–22
Compositional sketches 38–39
Constable, John 8, 34, 48, 70, 76–80, 86, 88, 96; *37, 50, 70, 76, 77, 78, 79, 87, 89, 90, 91, 93, 98*
Conté crayon 11
Conté pencils 10–11
Copying 142
Corot, Jean-Baptiste 9
Cotman, John Sell 8, 44, 63–67; *29, 49, 50*
Courbet, Gustave 9
Cowes, Victorian yachts *119*
Cox, David 8, 71–76; *72*

Daubigny, Charles 9
Detail 139
Drawing 10
 beaches 48–54
 boats 83–119
 building up 19
 clouds 71–82
 materials 10–14
 rivers 54–70
 sea 23–53
 ships 120–141
 starting 17

Erasers 14
Estuary 55, Colour plate 1 facing page 60

Fenland 59, 117
Ferry 128
Finding a subject 15
Fishing 69–70

Gouache 13
Giallina, Angelos 101–105, Colour plate 3

Headlands 34, 44–45
Heightening 14
Homer, Wilson 9, 26, 37, 119; *42*, Colour plate 4 facing page 61
Horizon 17, 29, 34, 38–39, 44, 48, 59, 73–77, 80, 97
Horizon, as one third two third divisor 29, 56
Horizon, colour and tone at 13

Inshore sailing 109–119
Inspiration 8–9

Jung, C G 7

Light areas 19
Line, a convention 20
Lines 17–19, 20, 76, 83–86, 120–127, 142
Lowry, L S 23; *24*

MacColl, D S 105; *104*
Maritime art 8–9
Monet, Claude 9, 70, 100–101, 113; *68, 102, 112, 113*
Monro, Thomas 60; *60*
Moorings 54, 86–105
Mulock, Frederick 45; *47*

Night sky 82

Offing 34

Palmer, Samuel 34; *40*
Papers 11
Pastels 14
Pears, Charles 134; *128*
Pen and ink 11
Pencil 10–11
Perspective 71–77, 79, 124, 128
Planes, use in drawing 71
Platt, John 109; *106*
Preparation 15–22
Promontories 45
Prout, Samuel 88; *92*

Rain 82
Reflections 62–65
Rembrandt, Van Rijn; 67–69; *51*
Repair yards 109
Rigging 86
Rivers 54–69
Rock studies 34
Rocks 34, 37–38, 44, 70
Ropes 86–88
Rushbury, Henry 133; *134*

Sailing boats 139–142
Scrap yards 109
Sea 23–24
 its fascination 7
Sea birds 37–44
Serres, John Thomas 26; *27*
Ships 120–142
 sailing 139–142
 superstructures 124, 128–130
 proportions 128
Ships models 8
Sketch-book studies 128–132
Sketch books 17, 22, 56
Sketching notes 67, 56–57, 83–86, 88, 95, 113, 129–130
Skies 71–82
Starting 17–20, 142
Steeple, John 33; *31*
Steer, P Wilson 29, 138; *28, 137*
Subjects 15
Swell 27

Tackle 86
Tide 26
Tonal differences 71
Tone used to start drawing 53
Trees, and the beach 53–54
Turner, William M. 8, 56–58, 60–62, 77, 101, 111–117; *62, 81, 102, 111, 114,* Colour plate 2

Velde, Willem Van de 8
Viewfinders 15, 20–21

Wash, application of 12
Watson, James Fletcher 62; *63*
Wave crests
Waves 23–34
Whistler, James McNeill 9